C000256544

BRITAIN IN OLD PHO

AROUND NORWICH

NEIL STOREY

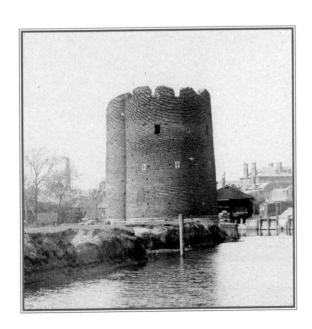

The History Press

Title page photograph: The Cow Tower, *c.* 1910. The tower was rebuilt in the fourteenth century as part of the city's defences. Its battered top is attributed to Kett's gunner Myles during the 1549 rebellion when he created havoc along the city defences with his well-placed shots from firepieces that had been siezed.

This book is dedicated to the memory and works of Eric Fowler (1909–81), the *Eastern Daily Press*' 'Jonathan Mardle'. His articles and books on Norfolk's history, dialect and character, along with the affection with which they were written, have interested and inspired thousands.

First published in 1996
This edition published in 2009

The History Press
The Mill, Brimscombe Port
Stroud, Gloucestershire, GL5 2QG
www.thehistorypress.co.uk

© Neil Storey 1996, 2004, 2009

The right of Neil Storey to be identified as the Author
of this work has been asserted in accordance with the
Copyrights, Designs and Patents Act 1988.

British Library Cataloguing in Publication Data.
A catalogue record for this book is available from the British Library.

ISBN 978 0 7524 5378 1

Typesetting and origination by The History Press
Printed in Great Britain

A royalty from every copy sold will go to the Norfolk Studies Library Restoration Fund

CONTENTS

Introduction 5

1. The City 7

2. Events and Entertainment 53

3. Emergency Services and Disasters 85

4. The Military 101

5. The Suburbs 111

 Acknowledgements 127

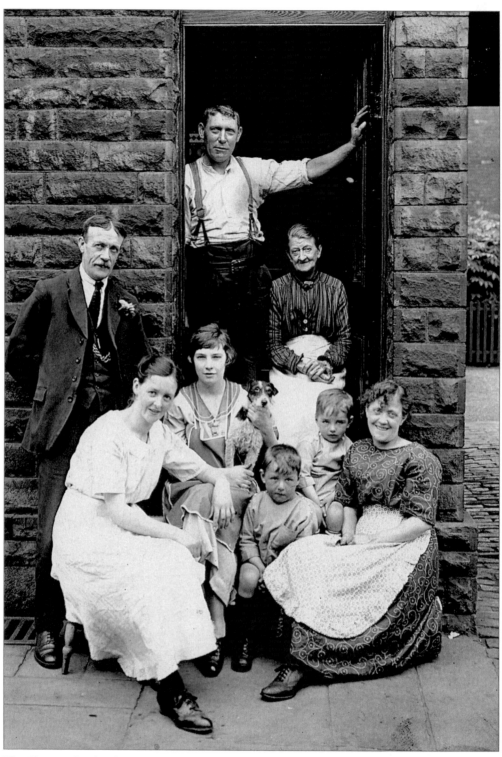

The Chapman family of Long Row off Waterloo Road, photographed by travelling photographer Tom Nokes of Chester Street in 1910.

INTRODUCTION

A fine old city, truly, is that, view it from what side you will; but it shows best from the east, where the ground, bold and heavy, overlooks the fair and fertile valley in which it stands. . . . Yes, there it spreads from north to south with its venerable houses, its numerous gardens, its thrice twelve churches . . . a grey old castle upon the top of that mighty mound; and yonder rising three hundred feet above the soil, from among those noble forest trees, behold that Norman masterwork, that cloud encircled cathedral spire, around which a garrulous army of rooks and choughs continually wheel their flight.

So wrote George Borrow (1803–81), the author of *Lavengro*, recalling his Norwich boyhood from his summerhouse on Oulton Broad. Although the city has undoubtedly changed dramatically since then and the choughs no longer circle the cathedral spire, when viewed from a good command the city in summer is still very green throughout, and the old description of the City of Gardens holds true.

This book looks at Norwich since George Borrow's words were written. It includes many early views taken by pioneering photographers in the last years of the nineteenth century, at a time when entrepreneurial photographers and publishers produced postcards of the views, people and events that shaped the contemporary history of Norwich.

Thanks to this legacy of historical pictures we are almost able to walk along the city streets of yesteryear when Jonathan Mardle wrote his *Wednesday Mornings*, William Childerhouse was the Bellman and 'Billy Bluelight' sold Leech's pills and raced the riverboats to Great Yarmouth at weekends. On market days the streets would be packed, bustling with carriers' carts and livestock driven through the streets by drovers and their 'penny boys', armed with sticks to stop them straying. In 1935, 212,000 head of stock were sold with sales of over £1,250,000 per annum; no wonder the pub snugs were packed with mardling farmers. At weekends crowds came to watch the 'City' play at 'The Nest' oxn Rosary Road or the legendary local boxer Arthur 'Ginger' Sadd at the Corn Exchange.

I make no apologies for this book's revel in sheer nostalgia. Some views will be familiar and some beyond recall, but it is a timely reminder as so much has changed. The great industries – weaving, boot manufacture, chocolate and brewing – which once employed the majority of city dwellers have disappeared, been dramatically depleted, or are under threat. It is reassuring, however, that Colman's Mustard soldiers on, as do local 'institutions' like Jarrold's, Bonds and Looses.

Carlyle said: 'Today is not yesterday; we ourselves change; how can our works and thoughts if they are always to be fittest, continue always the same? Change, indeed, is painful; yet ever needful.' This is very true of Norwich. Positive change is found in the Castle Mall and the conversion of old factories and warehouses into accommodation and offices instead of their demolition in favour of a fashionable eyesore. I am particularly impressed with the refurbishment of city pubs (once one for every day of the year). Wood panelling and traditional fittings have been reintroduced and are complemented by good fare and local ales. I consider them very worthy of regular study.

Much has been lost in the wake of progress since the demolition of the nine main city gates, along with sections of wall, between 1791 and 1801. Under this scheme to promote purification and circulation of air, it was even recommended that 'Hanging signs in every part of the city should be taken down: they are not only very dangerous and disagreeable in windy weather, but interrupt the view and impede the free circulation of air.' The recluses who lived in the tiny rooms above each gate, paying 8s 6d a year rent, were made homeless by these actions.

With the coming of the tram system one hundred years later, many historic buildings were demolished, including the home of Sir Thomas Browne, despite the protestations of the mayor and notable historian, Walter Rye. Some of the most horrific damage was inflicted during the Second World War. Norwich was targeted in 1942, along with other cities of historical significance, when Hitler launched what became known as 'The Baedeker Blitz' in an attempt to break morale. Over two nights, 27–8 and 29–30 April, hundreds of high explosives and thousands of incendiaries rained indiscriminately over the city, setting it alight and destroying civilian homes alongside shops, pubs and churches.

However, some of the worst destruction of historic Norwich streets and buildings shamefully occurred during the postwar years when architects were engaged to redesign Norwich. The published 1945 plans promised large open plazas in central areas, as well as inner and outer ring roads. Luckily, many of the ideas were not adopted, but the roads went ahead and consequently the old streets like Magdalen Street, St Stephen's Street and the Grapes Hill/Barn Road area were partially destroyed and reconstructed into the inner link road. Look at the photographs herein and decide which you would rather have.

Many local citizens have ardently campaigned for the preservation of the old city. The Norwich Society has battled to such an extent that when the original Whitefriars Bridge, dating from 1106, was due for demolition under the river-widening scheme, it was carefully dismantled. Each stone was numbered and stored by the Norwich Corporation until it could be reconstructed elsewhere. While in storage, it was espied by a work gang who used it for filling in holes during construction of the new Aylsham Road. Sadly, it could be argued that what the Luftwaffe didn't destroy the respective local Councils have had a damn good bash at!

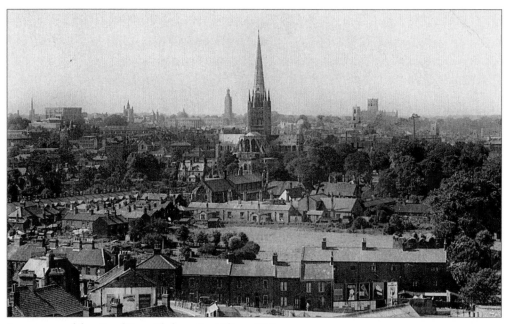

A panorama of the city of Norwich from Gas Hill, c. 1939.

SECTION ONE

THE CITY

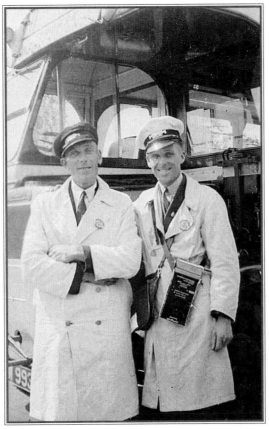

Eastern Counties Omnibus Company Ltd driver and
clippie beside their No. 11 bus, c. 1947.

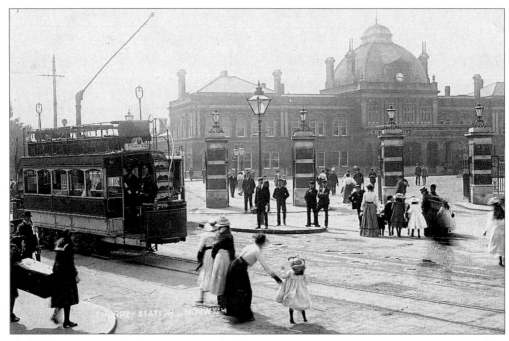

Thorpe station, *c.* 1904. The station opened in 1886 with its zinc dome and fine French baronial façade constructed by Youngs & Son, builders of Chapelfield Road. Norwich's first station, situated a short way down river, was opened on 30 April 1844 as the Norwich to Yarmouth line of the Eastern Counties Railway.

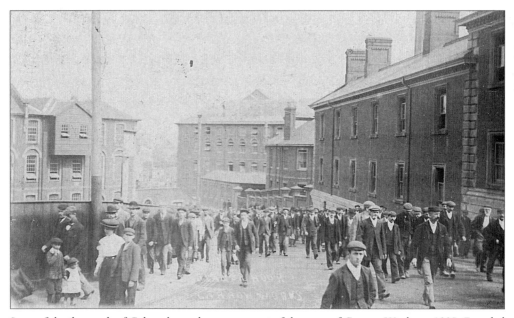

Some of the thousands of Colman's employees pour out of the gates of Carrow Works, *c.* 1905. Founded at the beginning of the nineteenth century by Jeremiah Colman, the business grew to be one of Norwich's largest employers by the beginning of the twentieth century, producing laundry blue, flour, semolina and their world famous English mustard.

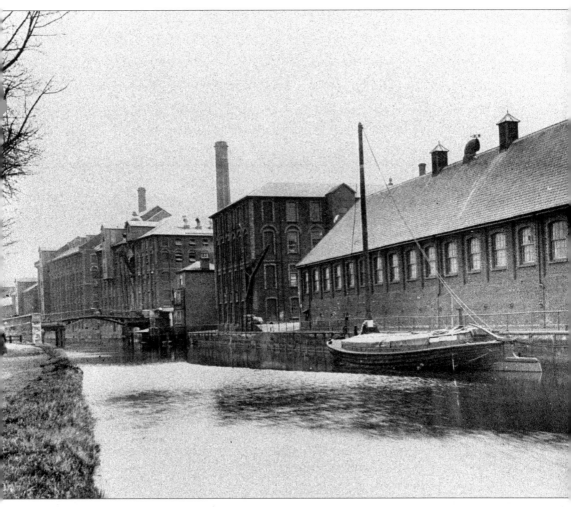

The River Wensum at Carrow Bridge with the wherry *Star of Hope* on the right, *c.* 1905. This ancient river crossing has acted as a gateway to the city for centuries. Just beyond the bridge are the Boom Towers constructed as part of the city's defences under Spynk's Charter of 1343. Here were suspended 'two great chains of Spanish iron across the river with the machines wound by a windlass in the tower on the west so that no ship nor barge nor boat might come in nor depart . . . against the will of those who have to govern the city'. This Carrow Bridge was demolished in 1922 for construction of a new bridge opened by HRH The Prince of Wales in 1923.

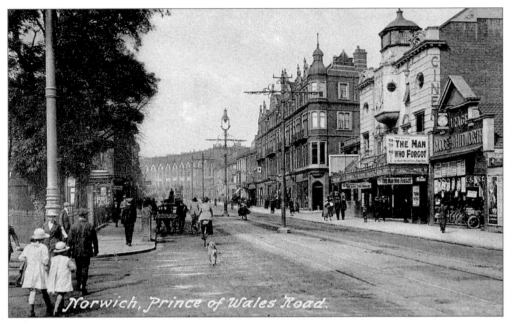

Prince of Wales Road, *c.* 1925. Constructed through the gardens of houses as a commercial speculation in the 1860s, it provides a valuable link between the city and Thorpe station. A number of prestige dwellings were built here, including Alexandra Mansions – the city's first residential flats.

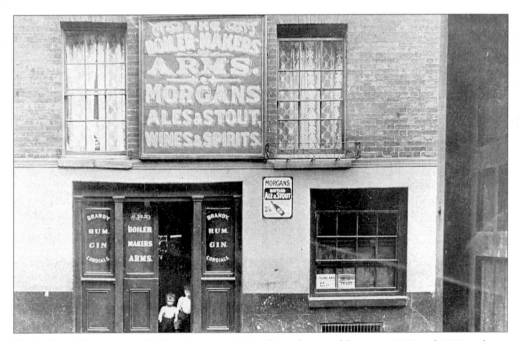

The Boiler-Makers Arms, 57 King Street, *c.* 1910. This pub existed between 1867 and 1929 and was kept for a number of years by Frederick Marris who also hired out carts for market traders. This was just one of the forty-three pubs and beerhouses with such names as Nelson's Monument, The Green Man and The Elephant and Castle that ran along King Street at the turn of the twentieth century, along with three breweries and twenty malthouses.

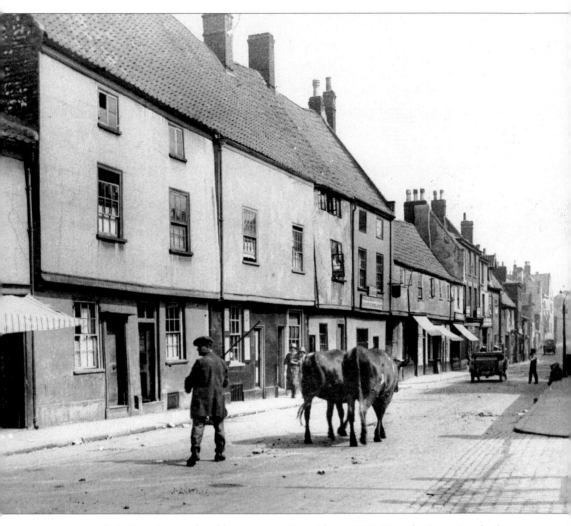

A drover and cattle in King Street, the oldest street in Norwich, *c.* 1925. Here the Saxons made their settlement, which became known as Conesford (the King's Ford), beside the old Roman marching route running from near Carrow Bridge along King Street to near Fye Bridge. A street of fashionable houses until the eighteenth century, it includes the Music House with its Jacobean façade which was built around 1175 by Jurnet, a Jewish moneylender. One of the wealthiest men in England and acting as the bishop's agent, he provided the money for the cathedral extensions. The building was later known as the Music House because the renowned City Waits or minstrels met there. Five in number, these were the city's first official musicians–constituted in the reign of Elizabeth I.

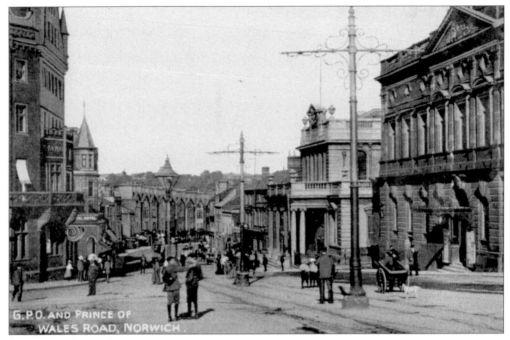

Agricultural Hall Plain, looking down Prince of Wales Road, *c.* 1912. The first building on the right is the Agricultural Hall designed by John Bond Pearce FRIBA of Upper King Street, which was opened in 1882 by HRH Edward, Prince of Wales. Next to that is the distinguished Bath stone building originally erected by Sir Robert Harvey Bt as the Crown Bank, which opened in 1866. After the tragic collapse of the bank, the building became Norwich's General Post Office and it is now occupied by Anglia Television.

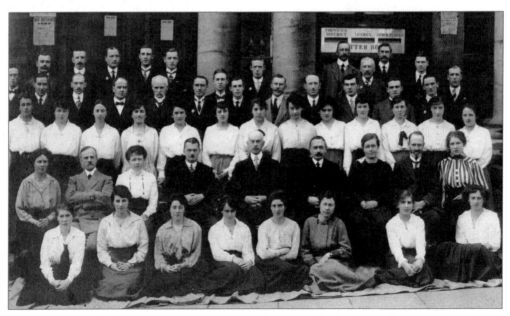

Norwich General Post Office staff gathered between the coupled Ionic columns that adorn the porticoed entrance to their grand Prince of Wales Road offices, *c.* 1915. Postmaster Henry John Walter Oakley is seated in the centre.

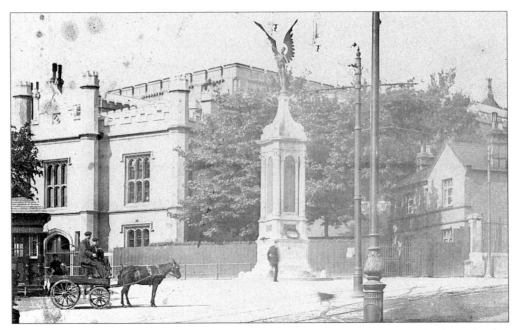

The Shire House and War Memorial to the 300 Norfolk men who lost their lives in the Boer War, pictured shortly after the memorial's opening by Major-General Wynne in 1904. On the left is the Shire House or Hall designed by William Wilkin Esq. Building commenced in 1822 and it opened in 1833 as the County Court House.

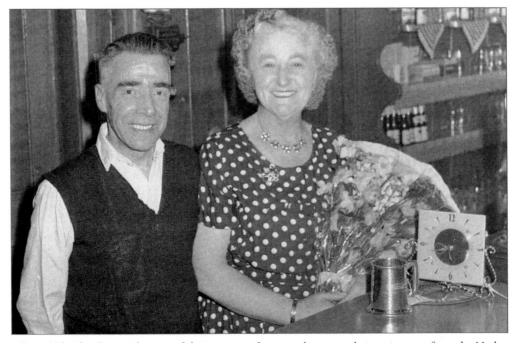

Billy and Flo Slaughter with some of their presents from regulars upon their retirement from the Market Lane Tavern in December 1960. The pub was situated at 14 Market Lane between Scoles Green and Paradise Row.

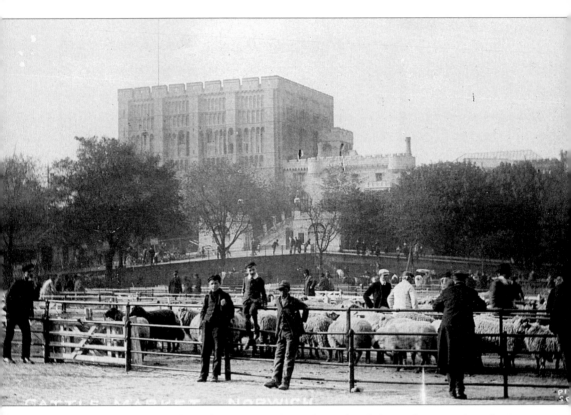

Norwich Castle and Cattle Market, *c.* 1906. The castle was founded according to tradition by Gurguntus, 24th King of the Britons. Known as Kaer Guntum, it was surrounded by a moat with a large bailey on the open space which became the cattle market. The wooden Norman keep was replaced by one in stone around 1120. In 1220 the castle became the County Gaol. The prison was extended and modernized over the years, but the most drastic changes came between 1824 and 1839 when the prison was enlarged for 224 male prisoners and Savin controversially refaced the whole of the keep in Bath stone. The prison remained until August 1887 when the prisoners were transferred to the new prison on Mousehold Heath. After a major conversion costing £22,474 the buildings became the Castle Museum, which opened on 23 October 1894.

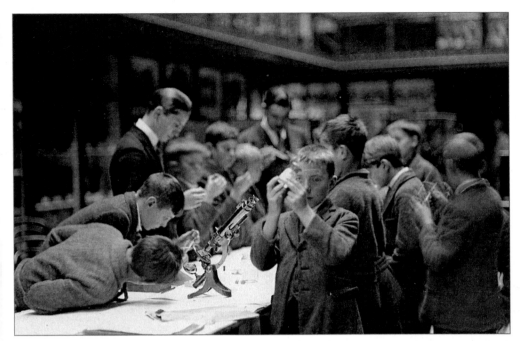

Schoolboys taking part in a natural science lesson in Norwich Castle, *c.* 1920. Four demonstrations were given daily, each class consisting of twenty-five senior boys or girls aged fourteen or above. The scheme allowed 500 scholars to attend a full course of twelve consecutive demonstrations.

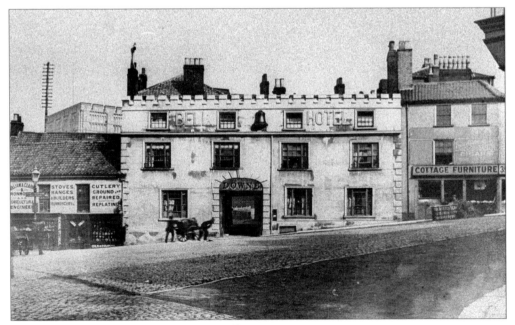

The Bell Hotel, *c.* 1895. One of the city's last surviving coaching inns, an alehouse has been on this site since the fifteenth century. Once known as the Blue Bell, many unusual clubs have met here including the Revolution Club founded in 1793. Embracing the views of the French Revolution, according to a government investigator the members of the club were 'of the lowest description'.

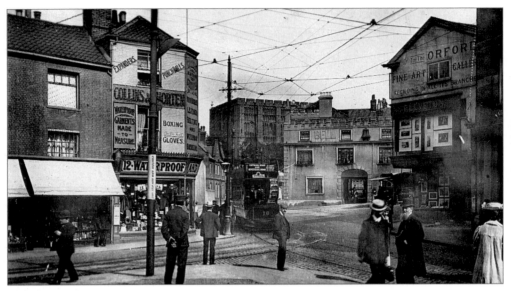

Orford Place, *c.* 1909. Methodists gathered in Orford Place and over Orford Hill in 1754 to hear sermons from John and Charles Wesley. The meeting was broken up by a mob bribed by members of the 'Hell-Fire Club' who met at the Bell. Violence was no stranger here; from the Bell up Timberhill to Ber Street was nicknamed 'Blood and Guts Alley'.

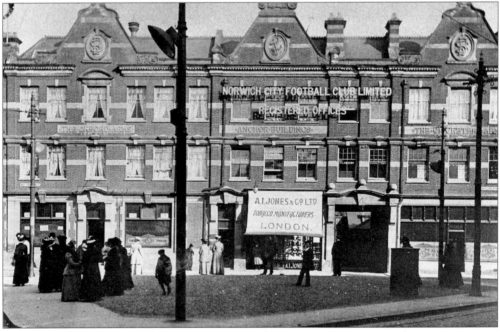

Anchor Buildings, Red Lion Street, 1905. Built at the turn of the century by Bullard & Sons, the buildings incorporated two pubs – the Cricketers Arms and the Orford Arms. No doubt they supplied the revellers for many civic occasions, especially on the first day of tram service in the city in 1900 as the terminus was situated almost opposite. On that day the crowds thronged Orford Place until after midnight.

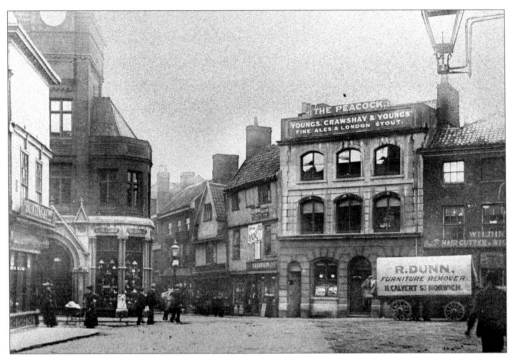

St Stephen's Plain, *c.* 1890. It has certainly changed beyond recognition. The row of timber-framed buildings beside The Peacock was demolished in 1900 during road widening for trams, and a new development designed by George Skipper replaced them. The fine Gothic building on the left occupied by ironmongers H.P. Colman & Co. was destroyed in the 1942 blitz.

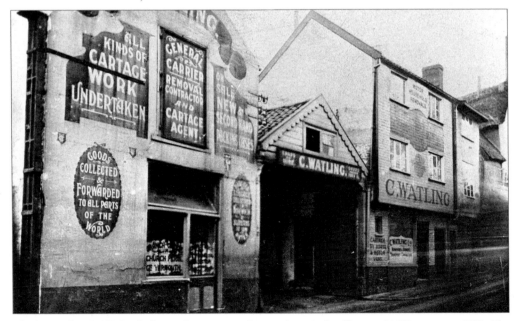

Charles Frederick Watling's forwarding agent and general carrier's offices at 14 Westgate, *c.* 1920. The office to the left was demolished in 1925 when the road-widening scheme was implemented.

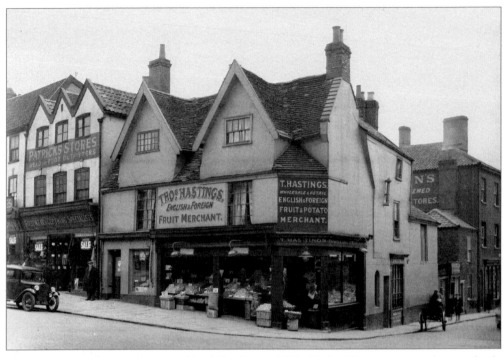

Thomas Hastings, fruit merchants, at No. 1 Ber Street, 1936. The building was soon to be completely demolished to become part of Bond's Department Store.

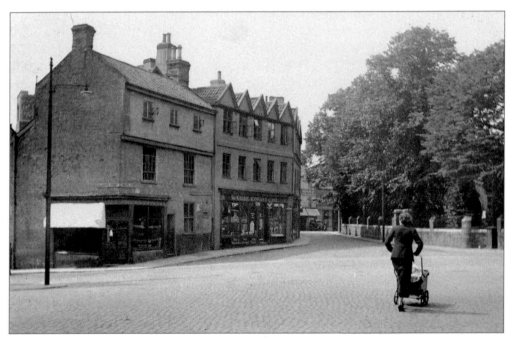

The corner of Timberhill, *c.* 1937. The road was named after the wood market held here when the hill was known as 'Durnsdale'. On the right is the churchyard of St John Timberhill. Those who died at the Castle Gaol were buried there, and also at the church of St Michael at Thorn which is no longer standing.

St Stephen's Street, always the busy entrance street into the city from the south, *c.* 1920. At the top of the street originally stood St Stephen's Gates, previously known as Needham Gates. This was one of the twelve fortified gates built at the turn of the fourteenth century that granted access to the inner city, but which were demolished in the late eighteenth century. The rest of the street was changed beyond recognition in favour of a road-widening scheme in the late 1960s.

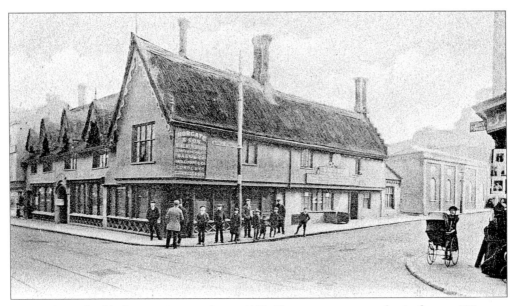

The Boar's Head public house at 2 Surrey Street, 1900. There was a tavern on the site for over 500 years. Originally known as The Greyhound, it was renamed after the boar's head on the arms of the Norgate family, which hung over the pub doorway when they owned the pub in the 1790s. It was remembered as a favourite snug for farmers on market days in the city before the Second World War, when it was burnt to a shell in the 1942 blitz.

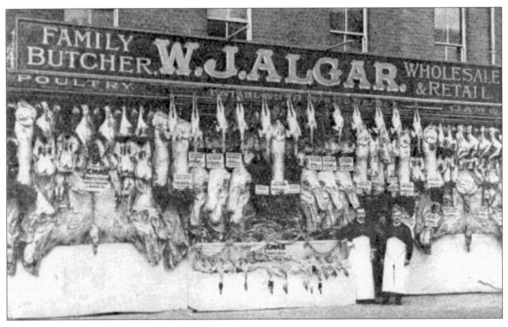

William Jabez Algar's wholesale and retail butcher's shop at 64 St Stephen's Street, *c.* 1920. Proud to have been a family butcher for over seventy years, they specialized in pork sausages and seasonal game. Their display is certainly impressive, but I wonder what the health inspectors would say today.

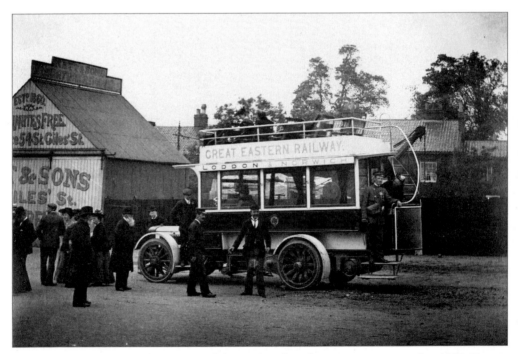

Great Eastern Railway's London to Norwich bus ready to board in Victoria station yard, *c.* 1905. Victoria station, situated between St Stephen's Road, Queen's Road and Grove Road, was opened in 1849 and closed to passengers in 1916.

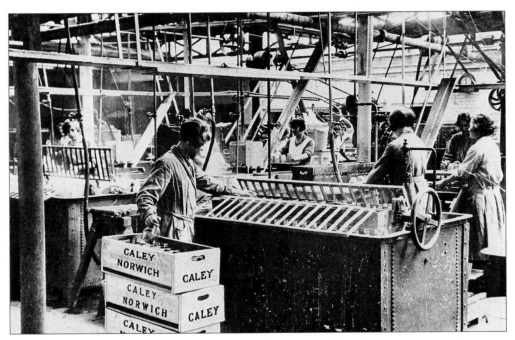

The sterilizing and machine filling room at A.J. Caley & Son's Chapel Field Works, 1921. Caley's manufactured mineral water and brewed ginger beer.

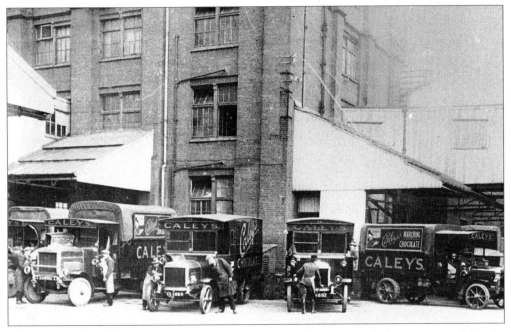

Caley's delivery vans in front of the Chapel Field Works, 1921. In 1932 the business was sold to the 'Yorkshire Toffee King', Mackintosh & Co. Ltd.

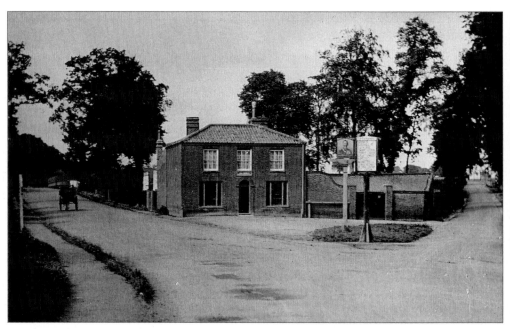

The King of Prussia public house at the junction of Ipswich and Hall Roads, *c*. 1910. During the First World War a group of angry soldiers tore down the sign and the pub's name was changed to the King George to avoid further incident.

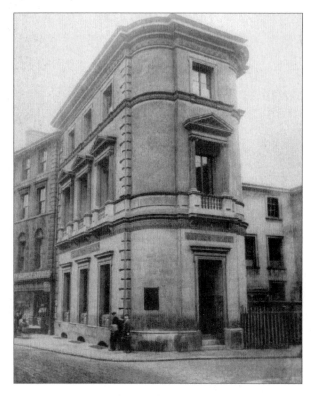

This fine building stood on the Haymarket from 1844 when it was purpose-built for the Norfolk & Norwich Savings Bank. Pictured in 1898, it was demolished a year later when the routes for tram tracks were being decided. The notable building on the right beside it, once the residence of Sir Thomas Browne, suffered the same fate.

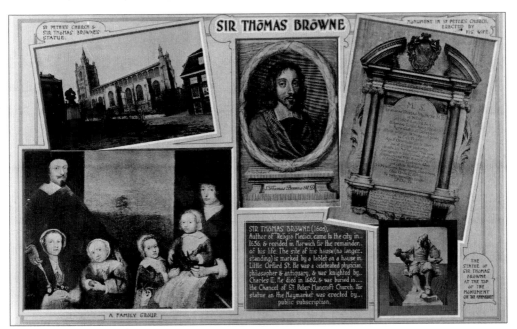

Often lost among the modern Haymarket is the fine statue of Sir Thomas Browne (1605–82). Settling in Norwich when aged 32, he soon became renowned for his medicine and writing, notably *Religio Medici*, his personal account and justification of the medical profession and his study, *Hydriotaphia* or *Urn Burial*, based on the urns found at Brampton. He was also one of the founders of the Congregationalist Church.

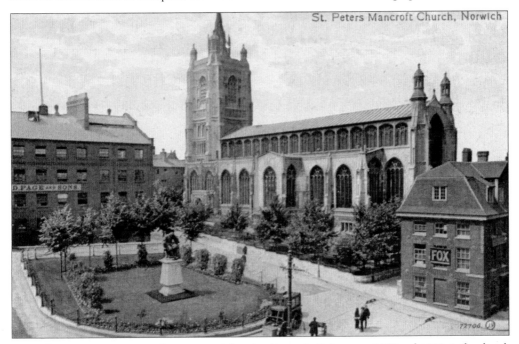

Hay Hill, *c.* 1910. Dominating the scene, as it has since it was built between 1430 and 1455, is the church of St Peter Mancroft. In 1715 the first true peals of 5,040 changes were rung with not one bell misplaced, and the church became renowned for its bell-ringers and the oldest peal board in the country. No wonder they had a 'gotch' or drinking pitcher holding 17 quarts, which was moulded by John Dearsley in 1749.

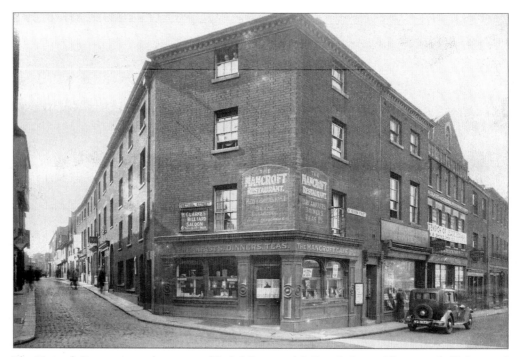

The Mancroft Restaurant on the corner of Bethel Street and St Peter's Street. This area of old shops and medieval and Georgian coaching inns was demolished in the late 1930s for the development of the new City Hall.

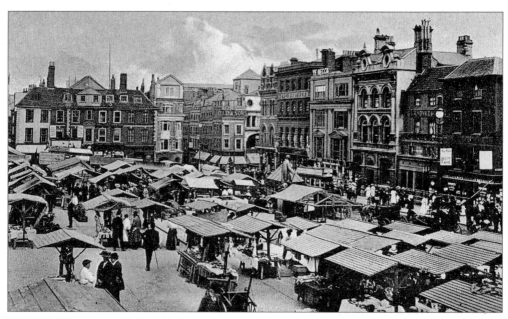

The Market Place, *c.* 1908. Hackney carriages line Gentleman's Walk along with the passing trams. Many of the shops such as Ye Mecca tea dealers, Hope Brothers' hosiers and Vandyke's photographers are long gone. Also now removed is the statue of Wellington made by G.G. Adams in 1851 and erected in 1854; it was moved to Almary Green in 1937.

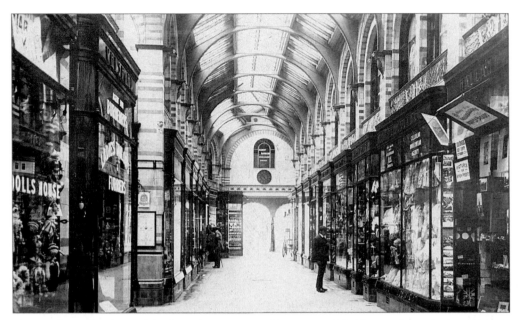

The Royal Arcade, designed by the architect George Skipper, *c.* 1907. The arcade was built in 1899 on the site of the Royal Hotel, which itself was named in honour of Queen Victoria on her marriage in 1840 and had been given a new front by Joseph Stannard in 1846 . Formerly the Royal was called the Angel, and was the headquarters of the local Whig Party.

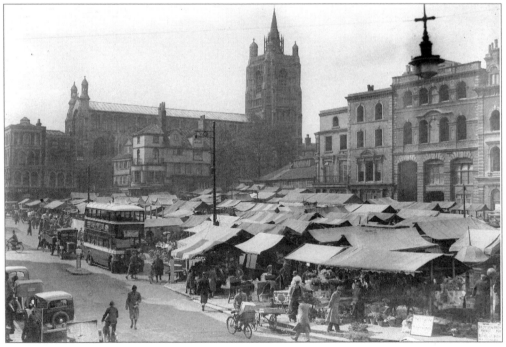

The Market Place with its clutter of stall tilts, *c.* 1933. Still standing behind the stalls are the once-grand Royal Exchange and the Waterloo Tavern, reduced to rat-infested, damp buildings used occasionally as overspill rooms for council departmental meetings. They were demolished in the 1930s.

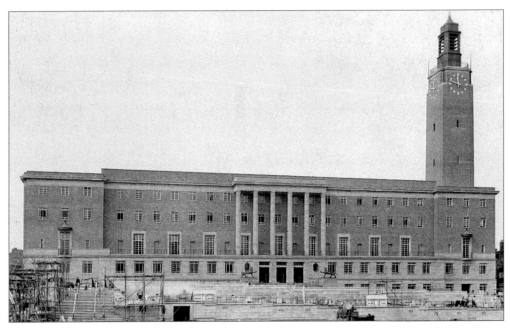

Norwich City Hall, 1937. Designed by C.H. James and S.R. Pierce, it was opened by HM King George VI on 29 October 1938. The new City Hall, contemporarily accused of 'resembling a marmalade factory', replaced the decrepit and outgrown civic buildings. Their demolition allowed a greatly extended Market Place together with new paving designed by Robert Atkinson and laid by Italian pavers.

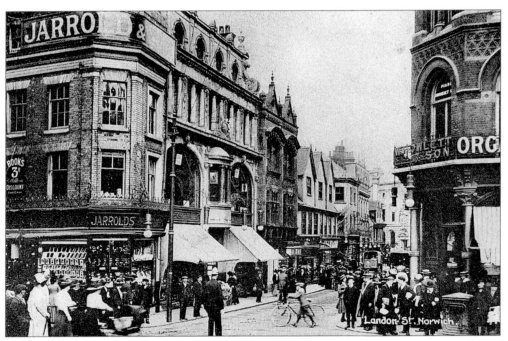

A bustling London Street, with the familiar name of Jarrold on the left, c. 1908. This end of the street was formally Hosiergate and progressed to Cutler's Row. In the eighteenth century it was called Cockey Lane after the 'cockey' or stream which once ran along the street.

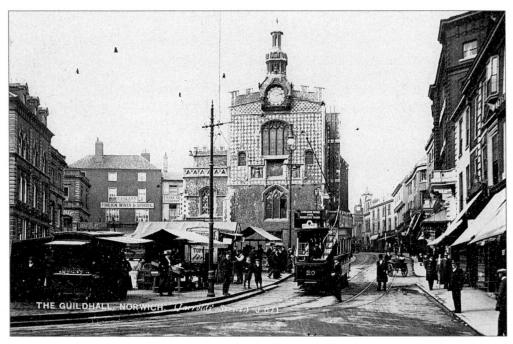

The Guildhall, *c.* 1910. Built between 1407 and 1413, the Guildhall replaced an old thatched toll-house which stood on the site. It gave the city a fitting administrative centre for its mayor and sheriffs under the 1404 charter, which was when the city was made a county in itself.

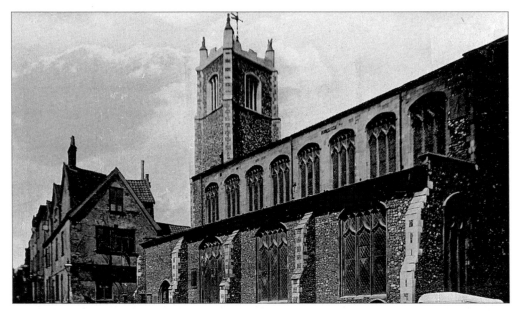

The Church of St John Maddermarket, which was built on the wealth of wool and weaving centred in this area of the city. The Madder Market was named after the madder seeds used in the dying of fleece and nearby Charing Cross comes from a corruption of Shearing Cross. It was into this churchyard that Will Kemp leapt to avoid the adulatory crowds receiving him after his morris dance from London to Norwich in 1599, which he completed in nine days.

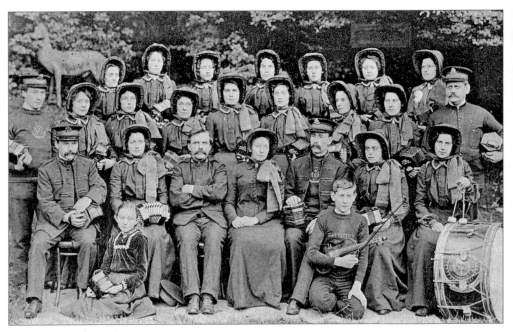

Norwich Salvation Army Citadel Concertina Band at the Salvation Army Citadel, 33 St Giles Street, *c.* 1908. It was considered unladylike to march and play cumbersome brass instruments, so concertina bands were popularized at Salvation Army mission concerts at the turn of the century.

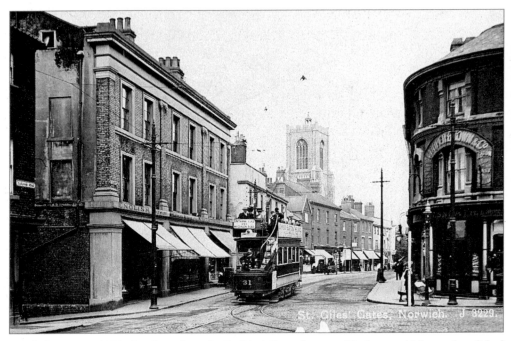

St Giles' Gates, *c.* 1906. On the right is the St Giles' Gates Stores public house which was demolished to make way for the inner link road. Still standing proud today on some of the city's highest ground is St Giles' Church with its 120 ft tower – the tallest in Norwich.

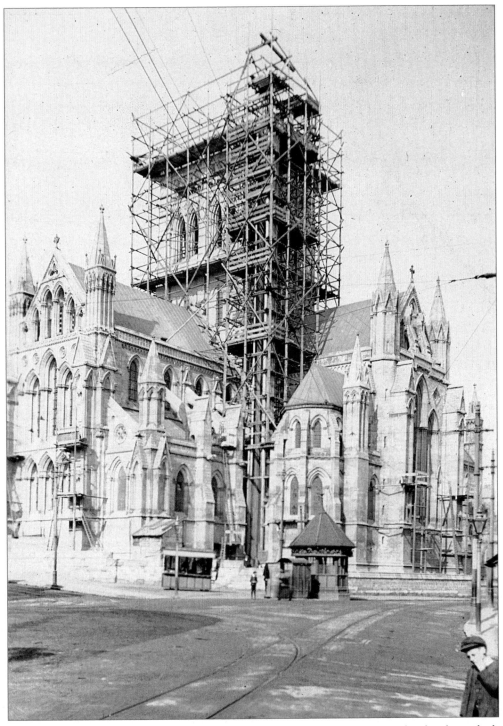

The Roman Catholic church of St John the Baptist during construction in 1909. The church was built between 1884 and 1910 with finance from the 15th Duke of Norfolk; it received the status of cathedral later. It stands on the site of the City of Norwich Gaol, which was constructed outside the city wall and used between 1827 and 1881.

Unthank Road, *c.* 1910. Up the road is the Park Tavern, now the Lily Langtry public house.

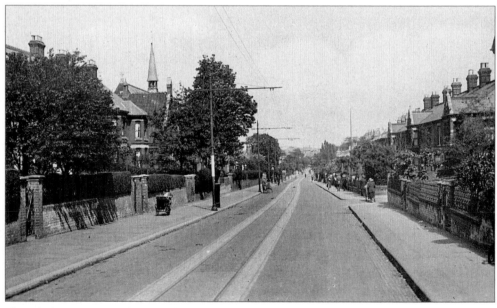

Through the trees we see the spire of St Thomas's Church, consecrated in 1888. The tram lines are empty on this fine Sunday afternoon on Earlham Road in 1925.

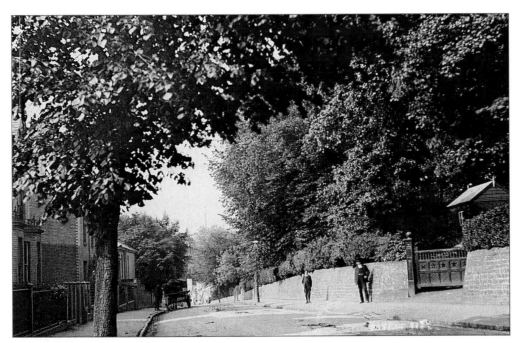

Mill Hill Road, *c.* 1906. The road was named after the nearby windmill which featured on Fadens' Map of Norfolk in 1797 when the area was spread with open fields. The major development of housing in Earlham began in the 1830s.

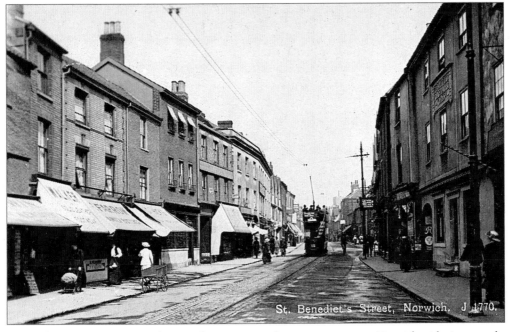

St Benedict's Street, *c.* 1910. This was the main westerly entrance street to Norwich with sixteen pubs and five churches along its length. It suffered terrible damage during the 1942 blitz.

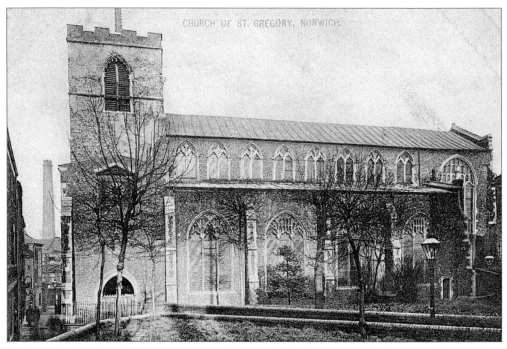

St Gregory's Church and Alley, *c.* 1904. Its tall east end is built over an alley which slopes down from Pottergate following the course of an ancient stream. This later became a processional route around the church.

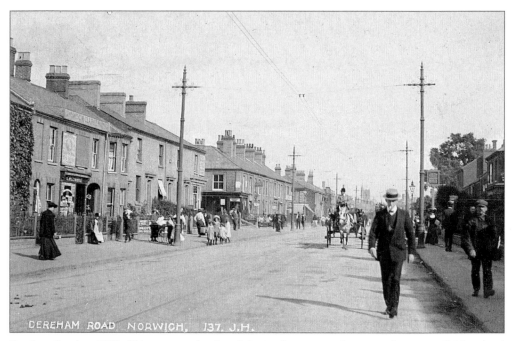

Dereham Road, *c.* 1908. This area was developed during the nineteenth century from open fields around an ancient trackway approaching the city. It led to St Benedict's or Westwyk Gate, which was adorned with the heads of malefactors as a warning to all entering the city walls.

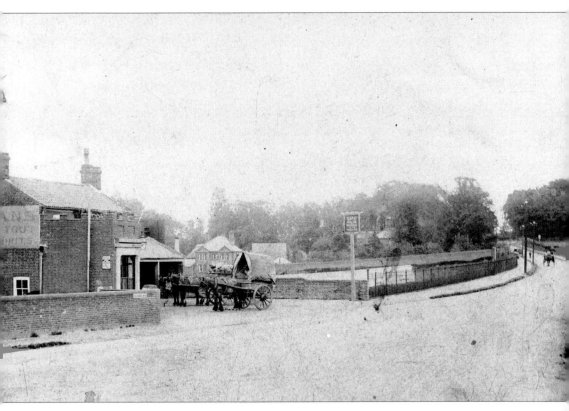

Upper Dereham Road, *c*. 1919. This road was greatly improved after 1770 when the Norwich, Swaffham and Mattishall Turnpike Trust was established and adopted the route. On the left is The Gatehouse public house, once the Norwich Gate House where the tolls were collected for the turnpike. A coach (except Royal Mail), gig or hearse had to pay 3*d*, dog carts, trucks or carriages were 1*d*, steam, gas or machine-driven vehicles paid 5*s* and driven cattle were charged at 10*d* per score head.

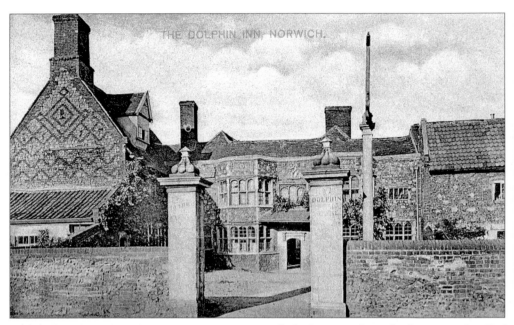

The Dolphin Inn, 258 Heigham Street, *c.* 1902. Originally built in 1541 by Richard Browne, Sheriff of Norwich, the building was known as the Bishop's Palace after its incumbent Bishop Joseph Hall, the forty-fifth Bishop of Norwich. Becoming an alehouse after the turn of the eighteenth century it was reduced to a shell in the 1942 blitz, but was restored in the 1960s by Steward & Patteson Brewers.

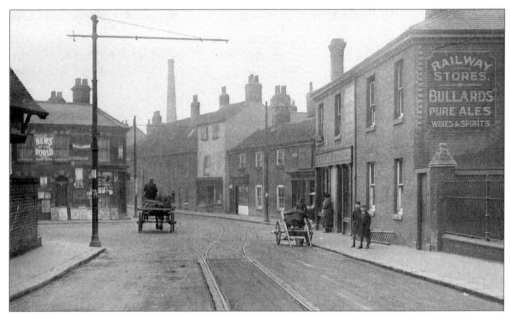

The junction of Barn Road, Westwick Street and Heigham Street, *c.* 1922. On the left is the gable end of the building known as the 'Monkey House', which was moved here from Whitlingham in 1900. This, along with the Railway Stores and most of this area, was destroyed in the 1942 blitz. The road has changed beyond recognition; if not through the bombing, then through the demolition gangs in the 1960s making way for the inner link road.

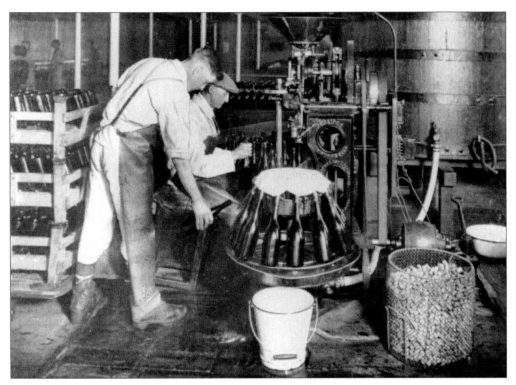

Coleman's Wincarnis Works filling room, 1937. The bottles are being filled with Wincarnis. Originally known as Coleman's Liebig Extract, it was devised as a medicated wine by William Coleman in 1881.

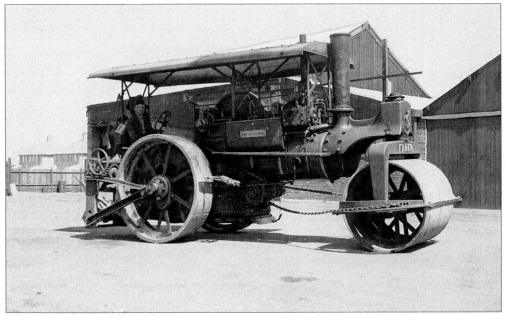

City of Norwich steamroller in the Westwick Street Corporation Depot, c. 1930. The steamroller was certainly kept busy over the 250 miles of adopted public highway in the city.

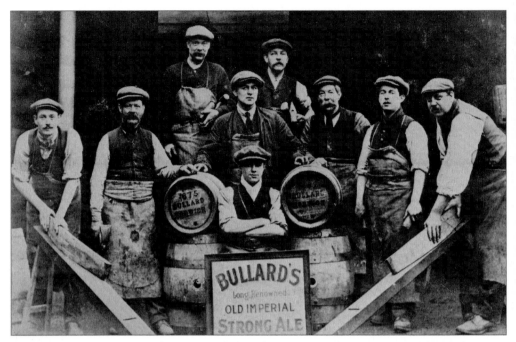

Bullard's Anchor Brewery workmen, St Miles' Bridge, 1912. Anchor Brewery was founded in 1837 on the site of an earlier brewer's house, that of Sir Peter Seaman who was Mayor of Norwich in 1707. Brewing ceased at the Anchor Brewery in 1968.

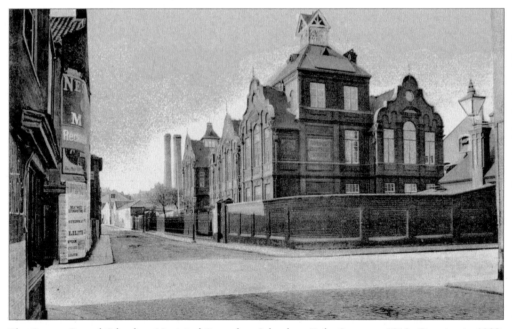

The Crome Central School or Municipal Secondary School on Duke Street, *c.* 1912. Opening in 1888, it had accommodation for 575 boys and 300 girls. In recent years it became the Duke Street Centre for sports and leisure activities until its closure in 1995.

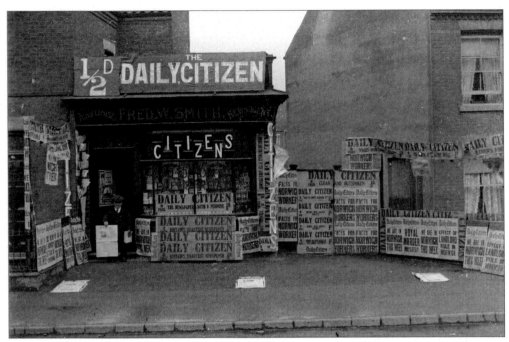

Frederick William Smith's newsagent and tobacconist shop, 76 Pitt Street, *c.* 1910. It is emblazoned with adverts for the special promotion week of the *Daily Citizen*: 'Britain's Smartest Newspaper'. On offer for your halfpenny, read all about the effect of landlord rule, facts for workers and the Lord Mayor's attack on cinemas in Norwich.

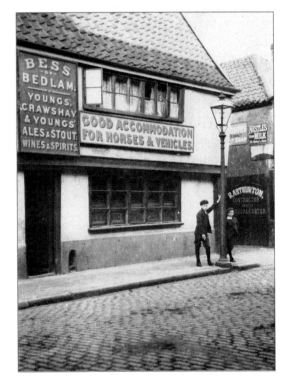

The Bess of Bedlam public house, 1895. At this time it was run by Robert John Arthurton, who was also a successful general carter and contractor at 80 Oak Street. The pub's unusual name relates to the Bethel or 'Bedlam' Hospital erected in 1713 on Chapelfield, for the 'habitation of poor lunatics and not natural born fools or idiots'.

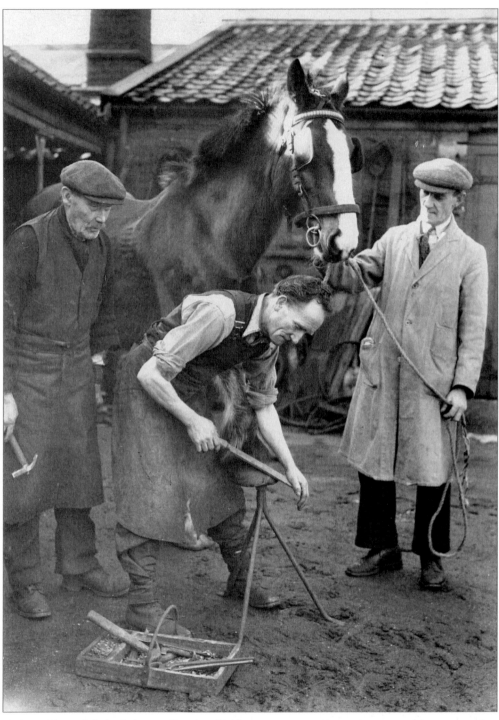

Blacksmith's Yard, behind the Royal Oak public house at 64 St Augustine's Street in the 1950s, when delivery cart and draymen's horses were still being shod here. The smithy was in the hands of the Francis family for over a hundred years. On the left stands Mr George Francis, a blacksmith for seventy years. His son files the hoof while the bread van roundsman Mr Frank Stannard holds his horse steady.

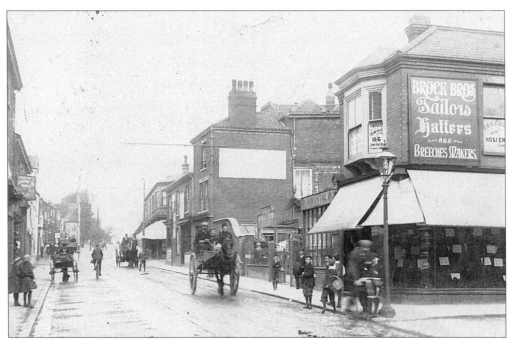

St Augustine's Street, *c.* 1903. This street was named after the Augustinian eremites or Austin Friars who settled and built their walled dwelling and cloister here during the fourteenth century.

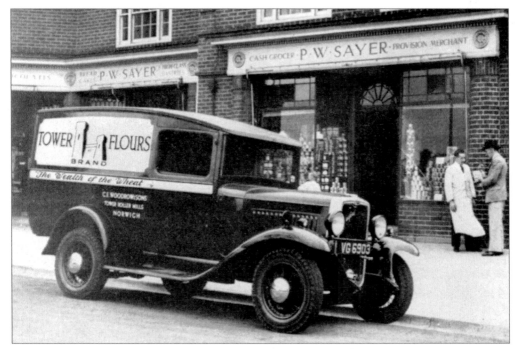

Percy Wilfred Sayer's cash grocer and provision merchants at 183 Drayton Road, 1937. The delivery is from C.E. Woodrow & Sons' Tower Flour Roller Mills on Eleanor Road, New Lakenham.

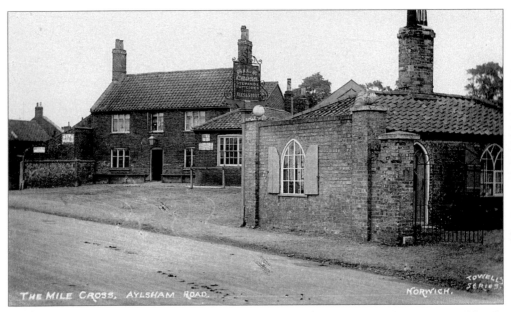

The Mile Cross Inn, Aylsham Road, *c.* 1910. A popular inn for over a hundred years, it stood beside the Norwich to Aylsham Turnpike which was established in 1796. The cart tracks are clearly visible on the forecourt. The name of Mile Cross is derived from the nearby mile boundary cross, one of several formerly standing on all entrance roadways into the city to mark the final mile to the city walls. This Mile Cross, once known as the White or St Faith's Cross, was moved in front of the Boundary Pub in 1927 when the road was widened.

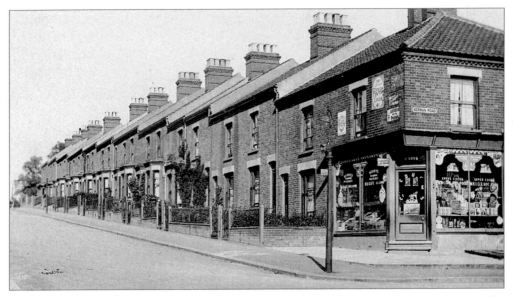

Pelham Road, one of the typical rows of terraced houses which sprung up around the city from the middle of the nineteenth century, *c.* 1912. They were often named after prominent local citizens or things associated with them. This road was named after the popular Bishop, John Thomas Pelham, who was the 65th Bishop of Norwich from 1857 to 1893. He retired through ill health and died in 1894. His recumbent figure on the memorial erected in 1896 may be seen in the cathedral today.

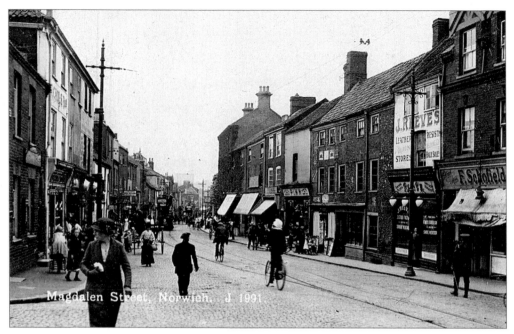

A bustling Magdalen Gates when it was one of the main shopping areas of the city, *c.* 1910. Known up to the nineteenth century as Fybrigge Street and Gate, near here was 'Maudly Gallows' where 300 of Kett's Rebels were hanged in 1549.

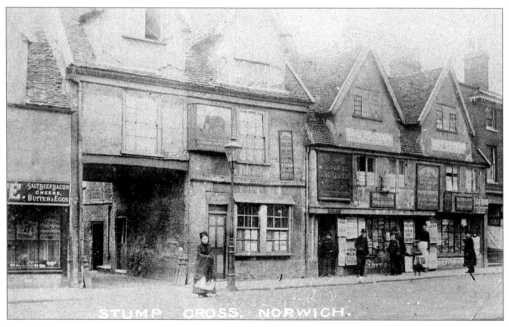

The Elephant public house, 60 Magdalen Street, *c.* 1902. At this time the landlord was George Attoe. This area, known as 'Stump Cross', was demolished in 1971 to make way for the Magdalen Street flyover.

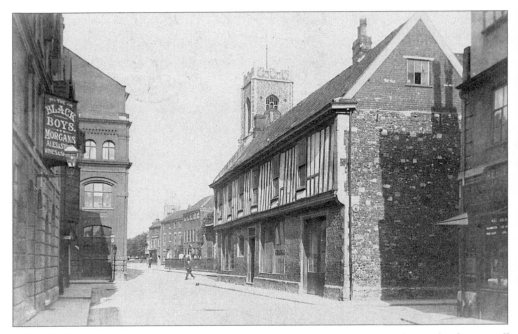

Colegate Street, *c.* 1909. On the left is the Black Boys Inn, now known as the Merchants of Colegate. Off this yard the Glover sisters ran a small school 160 years ago. Sarah Ann Glover taught singing with her own unique method eventually adopted all over the world: the tonic sol-fa of doh, ray, me, fah, soh, lah, te, doh.

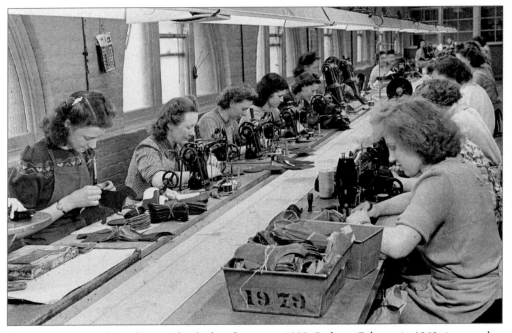

The machine room of Howlett & White's shoe factory, *c.* 1950. Built on Colegate in 1868, it opened as the largest shoe factory in the country and was eventually taken over by Norvic Shoes. At the turn of the century the shoe trade was the city's main source of employment.

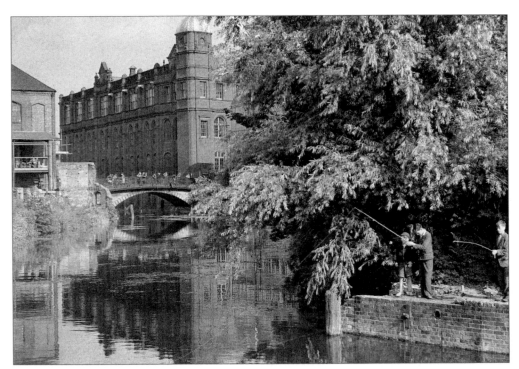

Boys fishing on the River Wensum, 1951. Behind them is Blackfriars Bridge, designed by Sir John Soane and built in 1783. The cast-iron railings were added in about 1820. Behind is the Norwich Technical Institute erected in 1899.

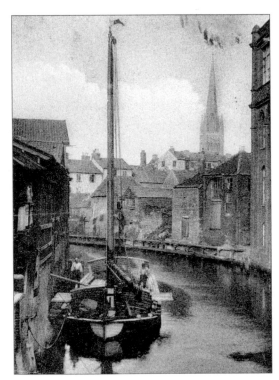

The quayside from 21 Wensum Street to Bedding Lane, viewed from Fye Bridge, c. 1904. This whole area, including across the river on Fishgate, was filled with warehouses and small dwelling yards and courts, such as Three Privy Lane and Cock and Pie Yard. Many of these are now demolished or vacated.

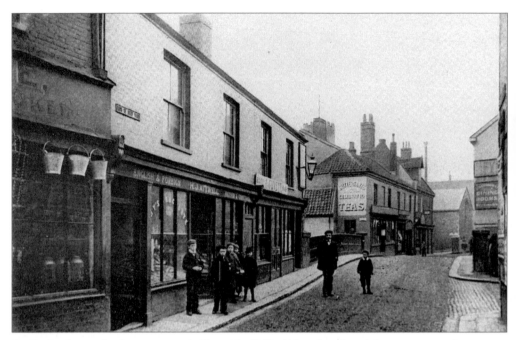

Fye Bridge Street, the shortest street in Norwich, 1899. Although its length has not increased in time, it was drastically changed under a road-widening scheme in 1933.

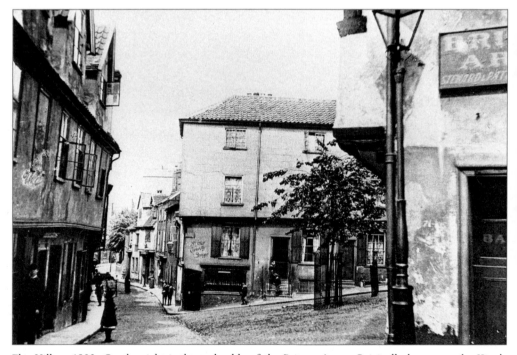

Elm Hill, c. 1903. On the right is the end gable of the Britons Arms. Originally known as the King's Arms, its name was changed along with revolutionary favour in the city at the end of the nineteenth century. Falling into disrepair, Elm Hill was saved from slum clearance in the 1920s by a carrying vote of one councillor.

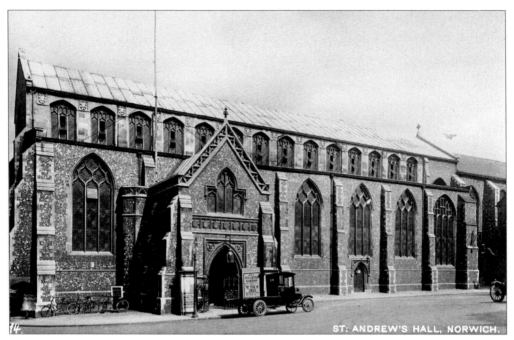

St Andrew's Hall, *c.* 1935. Originally the Dominican or Black Friars' Church built in the thirteenth century, it served as such until it was dissolved by Henry VIII and forfeited to the Crown. It was bought by the city for use as 'a fair and large hall for the Mayor and his brethren for assemblies' for £81, with another £152 for the lead on the roof! It is still a very fine meeting place today.

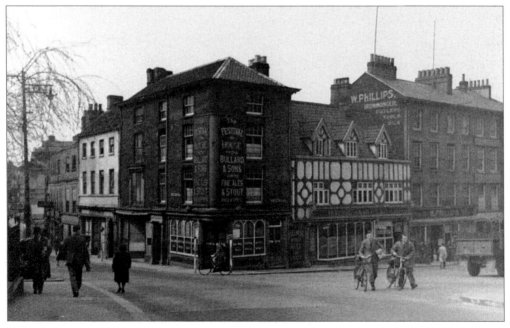

St Andrew's Plain, 1942. In the centre is the familiar sight of the Festival House, named after the Norfolk and Norwich Triennial Music Festival held at the nearby St Andrew's Hall since 1824.

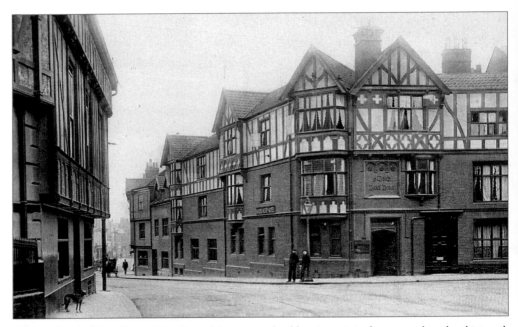

The Maid's Head Hotel, *c.* 1908. One of the country's oldest inns, it is documented in the thirteenth century when it was called the Molde Fish. On the left is the gable of the Waggon and Horses pub. Since 1976 this has been known as the Louis Marchesi after the founder of the Round Table, whose first meeting was held in Suckling House, Norwich in 1927.

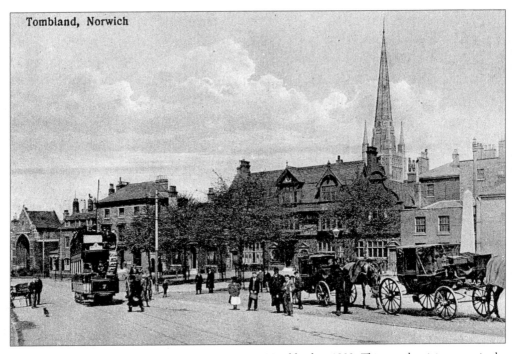

Cabbies wait by the roadway as a No. 7 tram passes on Tombland, *c.* 1903. This was the civic square in the growing settlement of Conesford, which along with the bordering settlements of Westwic and Northwic was to become the city of Norwich. Tombland is a corruption of 'tom land', which is Saxon for open space.

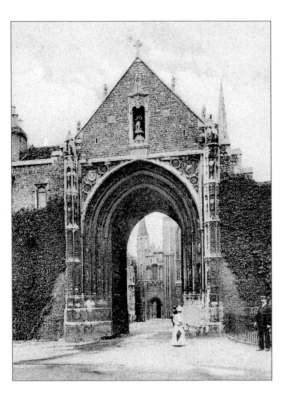

Erpingham Gate, *c.* 1903. It was built in 1420 as a thanksgiving by Sir Thomas Erpingham, the loyal Norwich knight who led the English archers at Agincourt in 1415, returning victorious. His kneeling figure may still be seen today in the niche over the gateway.

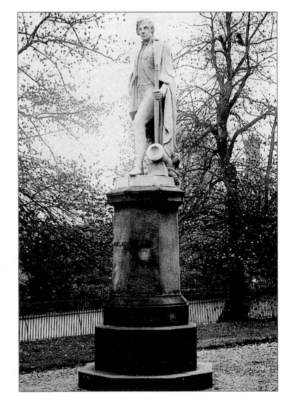

Nelson Monument, Almary Green, Upper Cathedral Close, *c.* 1910. This was carved by Sir Thomas Milne in 1847 who also sculpted the statue of the Duke of Wellington that once stood in the Market Place. It is apt that Nelson is facing the Norwich City School which he once attended.

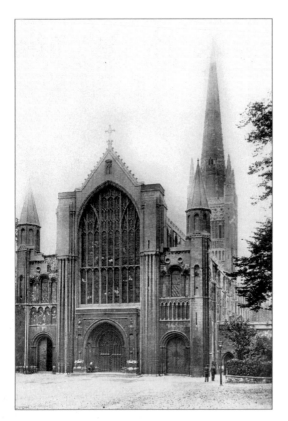

Norwich Cathedral, begun by Bishop Herbert de Losinga and consecrated in 1278. The spire was constructed in the fifteenth century, replacing the wooden spire destroyed in the hurricane of 1362. It rises over 315 ft and is visible on clear days from high points all across the county.

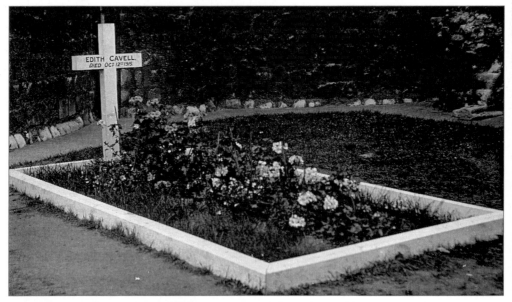

The final resting-place of the Norfolk heroine Nurse Edith Cavell at Life's Green (see also p. 59). Lying in a shallow grave at the rifle-range in Brussels where she had been executed in 1915, her body was exhumed and brought home to Norfolk in 1919. After a special memorial service in Westminster Abbey, her body was finally laid to rest here outside the cathedral.

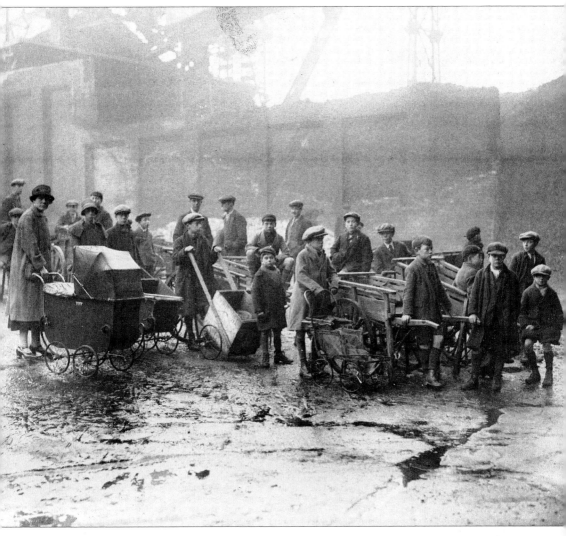

Children with boxwood carts and prams collect coke from the Palace Gas Works in the 1930s. Fuel was given away or sold at 6d for a large pram-full in the cold snaps during those austere inter-war years. Large stockpiles of coke were warily avoided after a heap was set on fire and burnt for a week in November 1925.

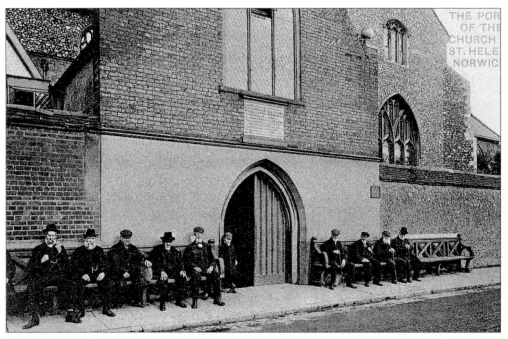

Residents mardle on the benches in front of St Helen's Church and Great Hospital, Bishopgate, *c*. 1905. The hospital was founded in 1249 by Bishop Walter de Suffield as a house for decrepit chaplains and to look after the sick and the poor. It served hot meals daily for thirteen needy people, who could also warm themselves by the fire. Endowed by Henry VII, the hospital grew and admitted more inmates, the good work continuing today.

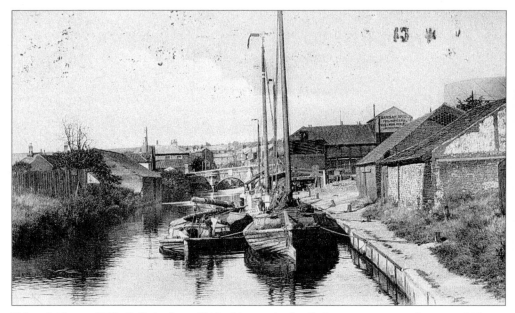

Bishop Bridge, *c*. 1900. Built in about 1340, this was the fortified east entrance to the city, which was stormed by the rebels in Kett's Rebellion in 1549. Prisoners, carrying their faggots, were led by monks across this bridge to be burnt at the stake in Lollard's Pit; many were later created religious martyrs.

Hay cutting on Mousehold Heath farm, 1930. This whole area of over 180 acres has been written about and painted by Norwich schools for hundreds of years. Many city residents took the opportunity of a 2*d* tram from Orford terminus to enjoy a day on 'Muzzle Heth'.

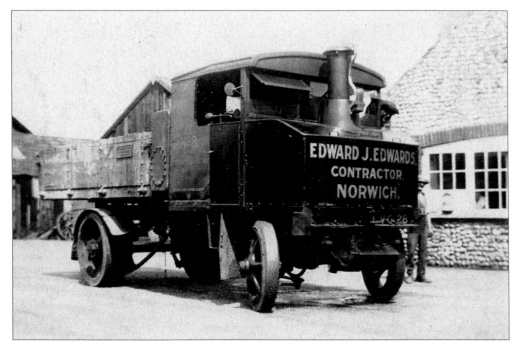

Edward J. Edwards' public works road and sewerage contractor's steam lorry, 1928. This was once a familiar sight in the city and district delivering builder's supplies, tar, granite and gravel from their Plumstead Road depot.

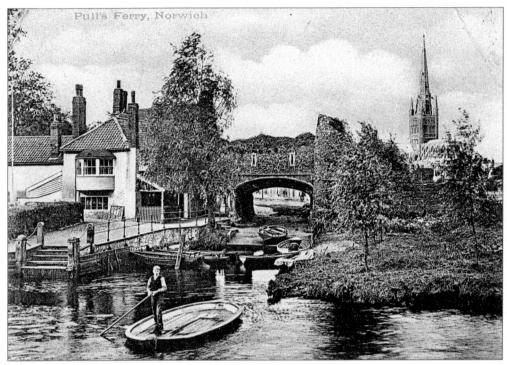

The ferryman pauses for this fine view of Pull's Ferry at the turn of the twentieth century. This fifteenth-century watergate once straddled a canal which transported the Caen stone for the construction of the cathedral and remained a watercourse until it was filled in during the seventeenth century. The ferry takes its name from John Pull who was appointed keeper of the ferry in 1796.

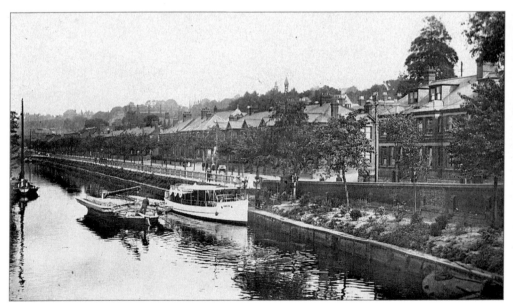

Riverside and the River Wensum, *c.* 1914, twenty years before the opening of the Yacht Station. Such a mooring was certainly necessary: in the first season 573 berths brought in around 2,600 visitors to the city.

EVENTS AND
ENTERTAINMENT

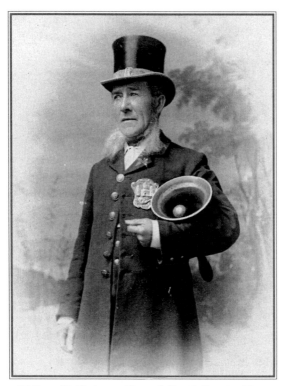

*William Childerhouse, Norwich City Bellman or Town
Crier, 1877–1905. His renowned stentorian voice and
ten-pound bell proclaimed the major events in the city.
Over his years of appointment he walked 70,000 miles
and cried 600,000 announcements on a Corporation
salary of 13s 4d per annum, with £5 a year for civic
sword-bearing and toastmastering at banquets.*

Trial, Execution, & Confession

OF

SAMUEL YARHAM.

For the WILFUL MURDER of HARRIET CANDLER, of Great Yarmouth, who was executed on the Castle Hill, on Saturday April 11th, 1846.

SAMUEL YARHAM was placed at the bar at the Norwich Assizes, for the Murder of Mrs. Candler, at Yarmouth, on the 18th of November, 1844. It will be recollected, that Mrs. Candler occupied the lower part of a house at Yarmouth, the upper part being held by an attorney named Catchpole. Yarham's wife was servant to him, and Yarham himself was allowed to persue his business of a shoemaker on the premises. At the time of the murder, Yarham, and three men, named Royal, Mapes, and Hall, were apprehended, and Yarham made a confession, implicating the three men in the murder. They were tried for the offence; each, however, succeeded in proving an alibi, and acquittal followed. So insensed were the public against Yarham, that he was obliged to quit Yarmouth. Subsequently Yarham made a confession to Mrs. Dick, (the individual who found the money that was stolen,) that he was the party who cut the old lady's throat; he was, in consequence, apprehended in Gloucestershire, and now appeared to take his trial. In a measure the testimony was substantiated by Mrs. Dick's daughter, who swore that Yarham was the identical individual who was observed, after the stolen property was found, poking in the sand for the treasure. Mr. Dasent made a powerful address to the jury in favour of the prisoner, arguing that the fact of Mrs. Dick having withheld this important evidence so long, was sufficient to throw distrust upon her testimony. The judge having recapitulated the evidence, the jury returned a verdict of Guilty, and the prisoner was sentenced to be hanged. The wretched man, who had listened to the trial with close attention and to the awful sentence of the Learned Judge without evincing any emotion, save a slight and occasional quivering of the lips and eyes, was then removed from the dock, while the shouts of the populace on the "hill" resounded in his ears.

CONFESSION

On the 19th of November Yarham stated to Mrs. Dick that he was the murderer, three weeks after that he met her in the market, and said, he let them (Mapes, &c.) in at the back door, he told them that she kept her money in her bedroom. While they were there Mrs. Candler came in sooner then they expected, on hearing her come in they put out the light, and sit upon the bed, Royal went in & asked for half-an-ounce of tobacco, and as she was getting it, Hall knocked her down with a pair of pincers, they thought she was dead. Mapes then ran to the Feathers' tap. As he was going along the Market Gates he saw a person turn a light on him, who afterwards appeared to be Layton. He then ran home telling the others to bury the money and give him a signal. When he went home he cut her throat with the lard knife. Royal gave the signal and he opened the window and saw Royal going down the street, a man came up and they both went away together.

THE EXECUTION.

This morning the above unhappy malefactor paid the forfeit of his life to the offended laws of his country. No execution of late years has attracted so large an assemblage of spectators, some thousands being present. About nine o'clock he took some refreshment, and shortly afterwards the sheriff arrived at the castle, and immediately proceeded to the condemned cell. The usual melancholy preparations having been completed, Yarham was brought to the room where he was to be pinioned. He appeared quite calm & collected, and walked with a firm step. The melancholy procession then proceeded towards the scaffold, which he mounted without any assistance, and in less than a minute the drop fell, and the wretched culprit was launched into eternity.

My hour is come, my glass is run, now by the law's decree,
On Saturday next condemn'd to die upon a fatal tree;
All for a cruel murder as all do understand,
Which has caused great sensation and horror thro' the land.
In vain I sought to cloak my crime, and steadfastly deny'd,
That I had been her murderer, and many schemes I try'd;
Thinking thereby to save my life, but vain was every plan,
For in the minds of all mankind I stood a guilty man.
When I review my wicked life, I shudder with dismay,
No consolation cheers me—a wretched cast-a-way;
No ray of hope revives my soul, to look beyond the sky,
While every moment seems to say, "To-morrow you must die.

The sacred laws of GOD and man I spurned with disdain.
Left no dishonest means untried, my purposes to gain;
But now my crimes have found me out, the blood my hands have
Now cries aloud for vengeance on my devoted head. (shed,
O could I for one moment a list'ning world address,
If in this world or that to come, the hope for happiness;
The ranks of factious traitors, as from destruction run.
Flee from those hellish counsels, which thousands has undone
For had I been by timely wise, and kept the honest way,
I might have been a prosperous and happy man this day;
But mark the sad alternative——I die by law's decree,
A wretched malefactor upon a fatal tree.

Walker and Co. Printers, Church Street, St. Mile's, Norwich.

Once a popular but macabre 'entertainment' for Norwich citizens was observing public executions held on Castle Hill. Broadsheets were sold among the crowds on the afternoon following the event at 1*d* a time.

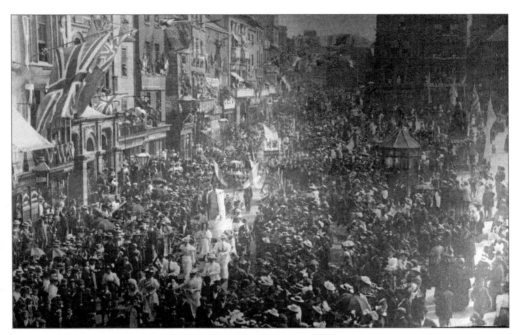

Thousands fill the Market Place to watch the procession and celebrate Queen Victoria's Diamond Jubilee on 29 July 1897.

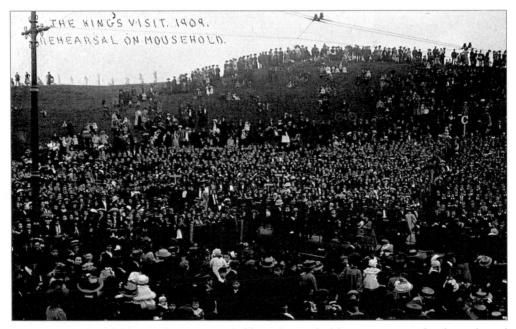

Over 11,000 schoolchildren gather on Mousehold Heath, watched by eager parents for their rehearsal of singing the national anthem in loyal greeting to HM King Edward VII on his visit to the city on 25 October 1909.

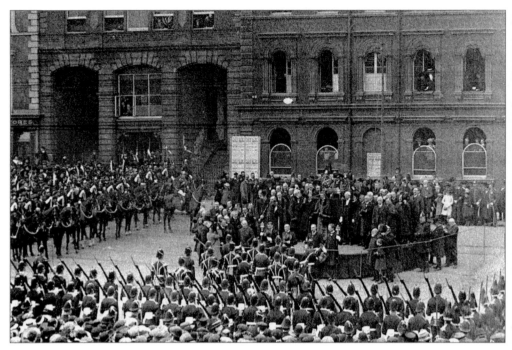

Crowds throng the Market Place in front of the old municipal buildings to hear the proclamation of the accession of HM King George V by Dr E.E. Blyth, first Lord Mayor of Norwich, on 9 May 1910. Forming the square are soldiers from the 17th Lancers, Norfolk Regiment and Norfolk Yeomanry.

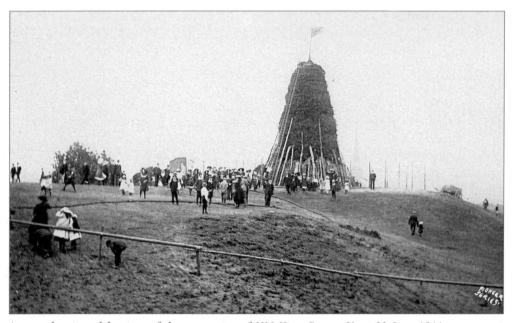

Among the city celebrations of the coronation of HM King George V on 22 June 1911 was a great firework display culminating in the lighting of this 30 ft high bonfire, a gift of the lord mayor.

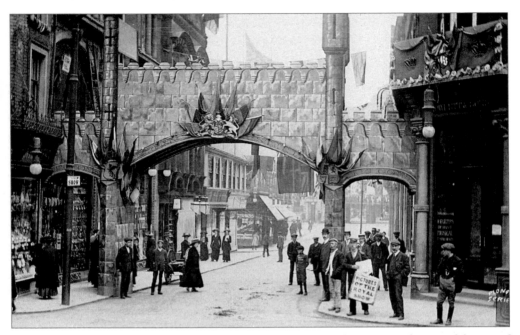

One of the arches over London Street assembled as part of the city's decorations in honour of the visit of
HM King George V on 28 June 1911.

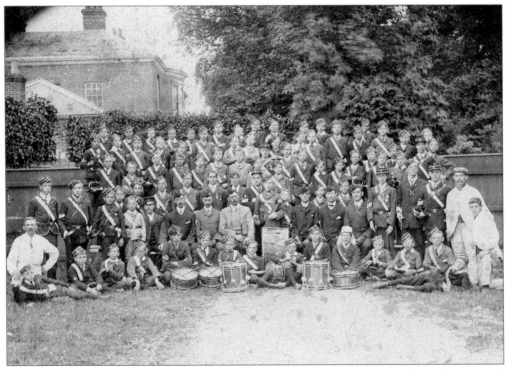

Norwich No. 5 Company Boys Brigade, c. 1905. The Boys Brigade was once a familiar sight on parade
down Barrack Street, led by the bugles and drums of their band.

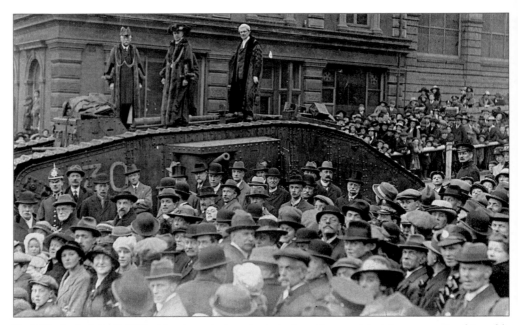

Tank Week, 1–6 April 1918. After its arrival on the train from the secret training area on Lord Iveagh's Estate at Elveden, the tank was driven up Prince of Wales Road, down London Street and manoeuvred into position in front of the Guildhall, drawing huge crowds on the way. Once in position, speeches were given from on top of the tank and anthems of the Allies were played.

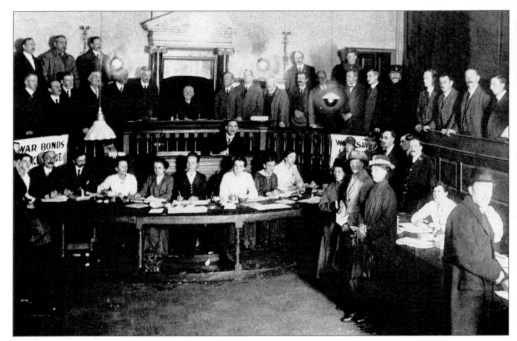

George Chamberlin, Lord Mayor of Norwich, presides over the sale of War Bonds in the Court of Record in the Guildhall for Tank Week in 1918. The incentive to buy the bonds was not merely patriotism, as purchase also entitled the bearer to inspect the tank. Tank Week realized £1,057,382 for War Bonds.

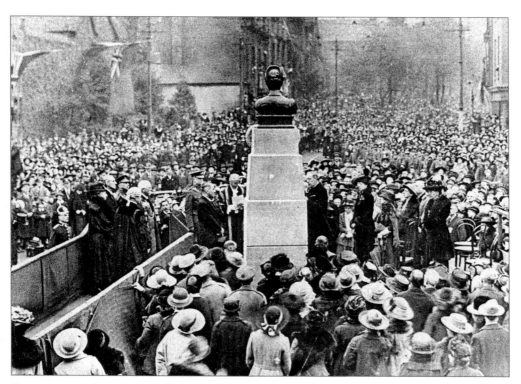

The opening of the Nurse Cavell Memorial by Queen Alexandra on 12 October 1918. This event was held on the third anniversary of the execution of Nurse Edith Cavell by a German firing-squad for her complicity in helping British soldiers to escape home.

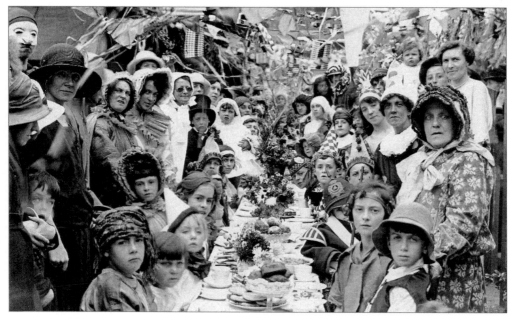

Armistice celebrations, 1918. The residents of Guernsey Road are holding a children's fancy dress party to raise a smile or two to 'Keep the home fires burning, 'til the boys come home.'

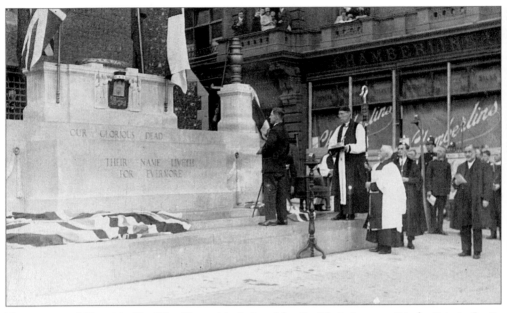

The opening of Norwich City War Memorial, designed by Sir Edwin Lutyens RA, by Private Bertie
Withers, a Norwich ex-serviceman, on 8 October 1927.

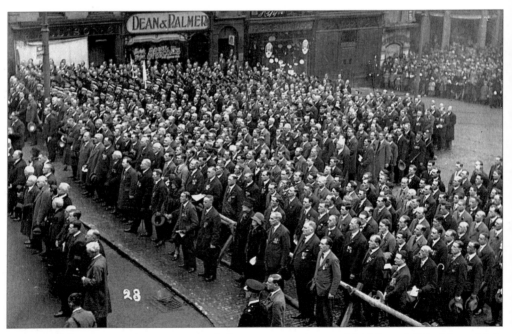

Fifty thousand veterans and spectators watch the opening ceremony of the Norwich War Memorial. It
is ironic that many of those who returned from the First World War were reduced to selling rags or
matches on the nearby market. So much for a 'Land fit for Heroes'.

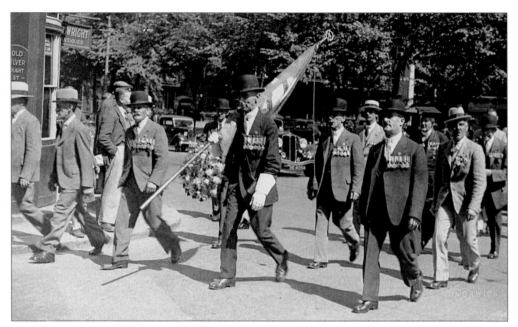

Members of the 'Old Contemptibles', those who fought at Mons, France and Flanders from 5 August to 22 November 1914, march across Tombland from their Associations' annual cathedral service, *c.* 1933. I wonder who remembers some of the other First World War veterans' associations, such as the Better 'ole Club on Castle Hill and the Comrades of the Great War Club on Prince of Wales Road?

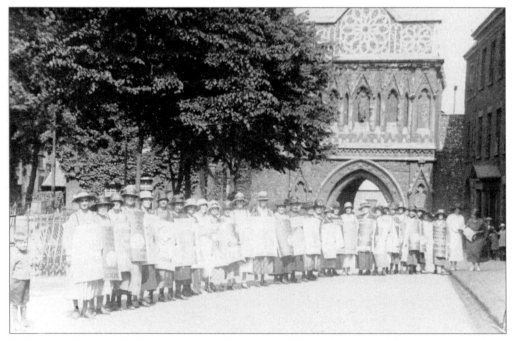

Suffragettes line up with their posters after being ejected from the cathedral for protesting during a service, *c.* 1912. They stand in front of the Erpingham Gate, a symbol of the Norwich citizens' struggle against religious oppression in the thirteenth century.

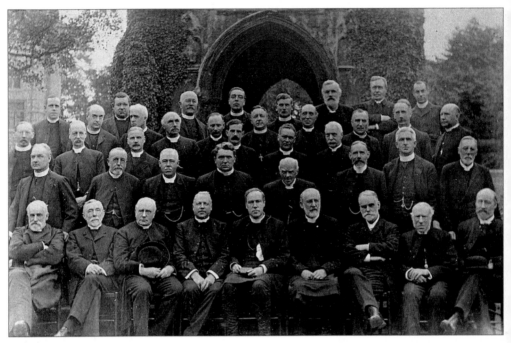

The Bishop of Norwich, Bertram Pollock DD, with visiting clergy in front of the Bishop's Palace on 13 August 1930. They are gathered to attend the commemoration service of the 1,300th anniversary of the diocese.

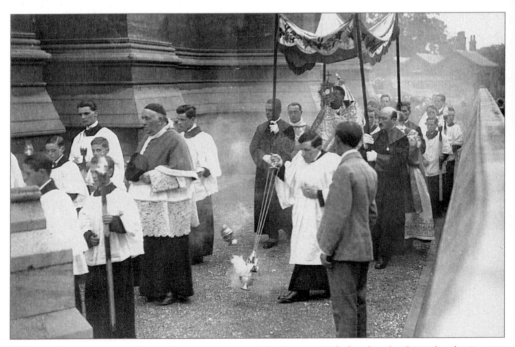

Officiants in lace cottas and cassocks process around the Roman Catholic church of St John the Baptist, c. 1920. The censers precede the priest carrying the monstrance in the ceremony of Blessing the Parish.

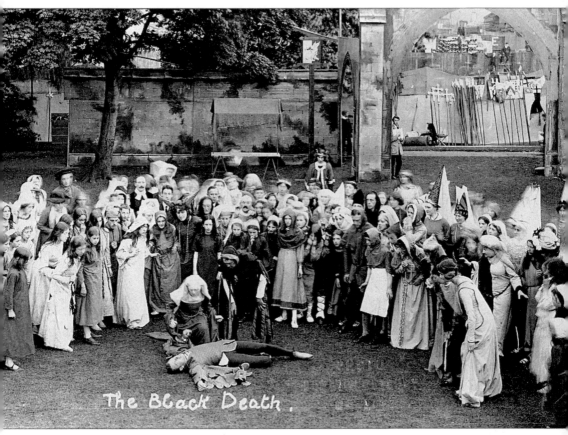

The Black Death.

'The Black Death 1349', one of the tableaux from the history of the city performed at the Norwich Pageant, 21–4 July 1926. Produced by Nugent Monck, of Maddermarket Theatre fame, thousands attended the event on Newmarket Road Ground with seats ranging from 1s 3d to 10s 6d. Other scenes included Emma and the Normans, Queen Philippa and the Weavers of 1336, and Kett's Rebellion of 1549.

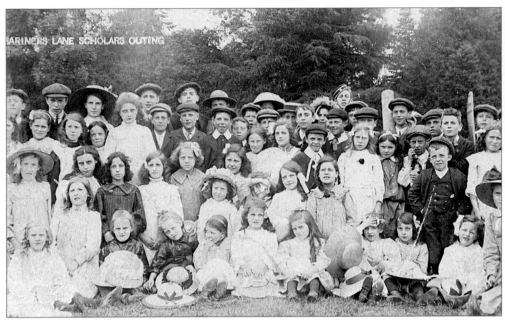

Formerly, one of the highlights of the year was the Sunday school summer outing and picnic. Taken to their destination in coal merchants' carts pulled by shire-horses decked over with ribbons and flowers, these youngsters are scholars from Mariner's Lane Sunday School off Ber Street on their day out in 1914.

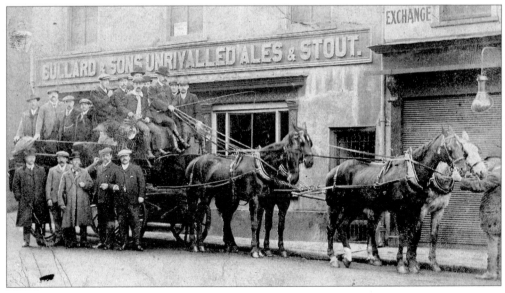

An outing to Yarmouth Races from the Ipswich Tavern, 4 St Stephen's Plain, 1908. The landlord, George Yallop, is seated to the right of the driver.

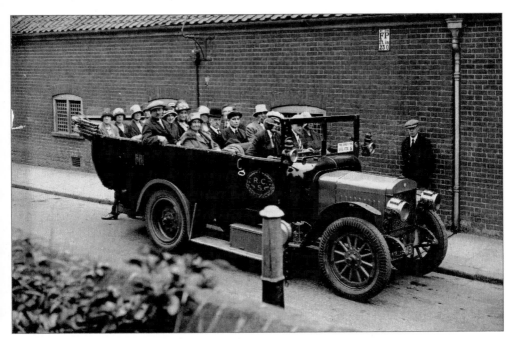

One of the five Norwich Red Car Services charabancs hired by Youngs, Crawshay & Youngs for their staff outing to Great Yarmouth, *c.* 1920.

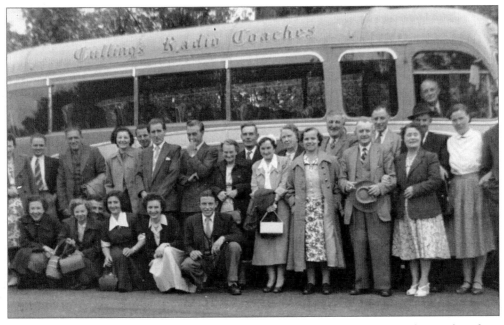

An outing to Great Yarmouth from The Trumpet public house, on one of Cullings Radio Coaches of Ber Street, *c.* 1958. The Trumpet stood at 72 St Stephen's Street until the 1960s when it was demolished. The Co-op restaurant now stands on the site.

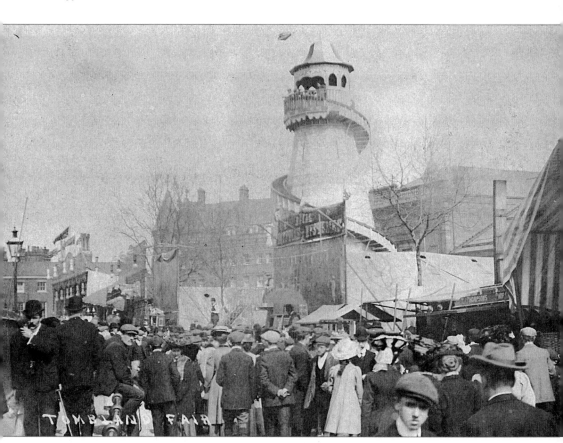

All the fun of Tombland Fair, c. 1908. Actually held on Castle Hill and Agricultural Hall Plain, the fair was moved from Tombland in 1818 following a complaint to Norwich Court of Mayoralty that it had carried on to unreasonable hours causing disturbances to inhabitants. The fair, held every Christmas and Easter since the twelfth century, has seen other more turbulent events. On Trinity Sunday in 1272 a fight broke out between locals and some men of the priory, resulting in the death of some citizens and a full-scale riot where citizens stormed the Cathedral Close. Many buildings and most of the cloisters were razed to the ground. Mercenaries were brought in, but it took Henry III to come in person to restore order. The city lost its liberty and became a Royal Manor, while the ringleaders were executed, the city was fined 3,000 marks to be given to the prior in compensation for damages.

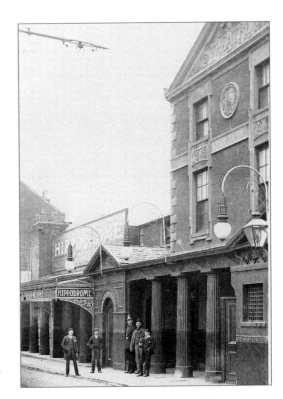

The Hippodrome, as it was called during the year 1903 when it was owned by Bostock and Fitt. One year later they established the Grand Opera House, renaming that the Hippodrome. This theatre then returned to its familiar name — the Theatre Royal.

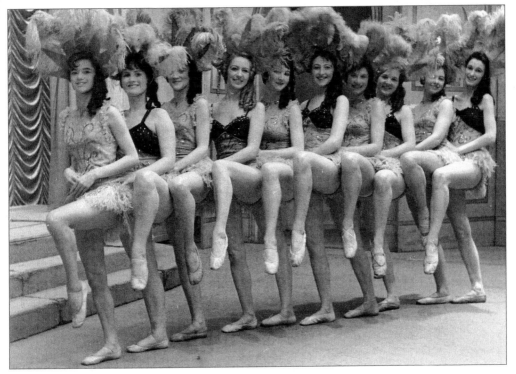

The chorus line of *The Gypsy Queen* at the Theatre Royal, *c.* 1960.

The Maddermarket Theatre, 1948. As a labour of love, Nugent Monck converted this one-time Roman Catholic chapel and baking powder factory into a replica Shakespearian theatre. It cost £3,300 and has provided a home for the Norwich Players since 1921.

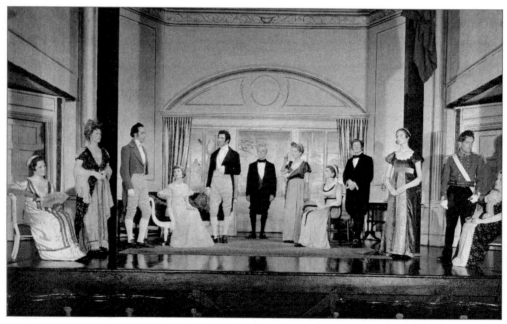

The Norwich Players' production of *Pride and Prejudice* at the Maddermarket Theatre, 6–14 June 1958.

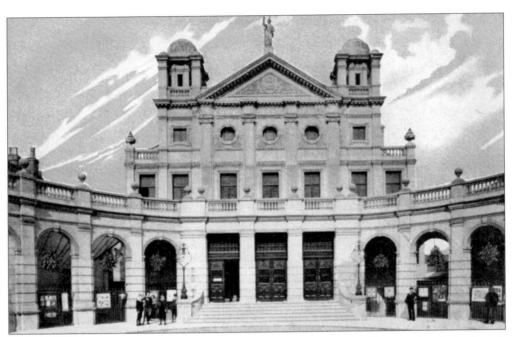

The Grand Opera House on St Giles' Street, *c.* 1903. This magnificent building was bought by Bostock and Fitt and became one of the best vaudeville theatres in the county, hosting many of the top acts of the day. Sadly, like so many theatres, it closed in the 1960s and was demolished to make way for a multi-storey car park.

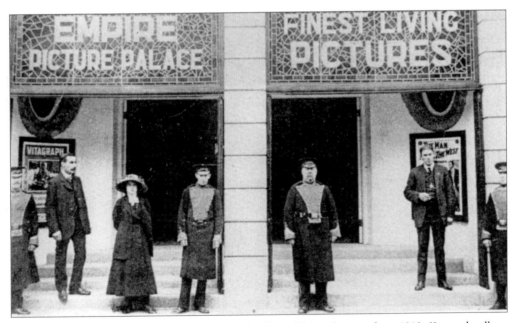

The staff of the Empire cinema, Oak Street, pose for this publicity photograph, *c.* 1913. Known locally as 'the flea-pit', entrance could be paid for with jamjars or rabbit skins. The inside was considered unsavoury at the best of times; during performances a pungent disinfectant was sprayed around by staff causing great consternation among picture-goers! This cinema struggled on until the late 1930s when it closed.

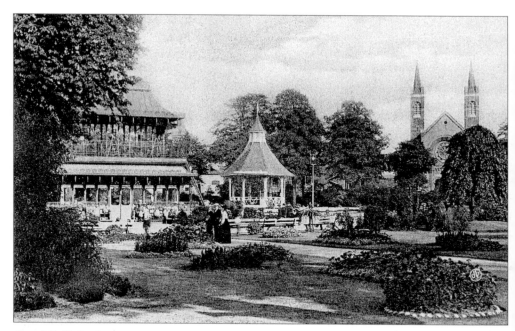

Chapel Field Gardens, *c.* 1905. An ancient archery ground and once a great reservoir, it was converted into pleasure gardens by the Corporation in 1880. The bandstand was host to many great performers, ranging from Marie Lloyd to Glenn Miller. On the left is the iron pagoda constructed by local iron founders, Barnard Bishop & Barnard. It was demolished in 1948, having become unstable.

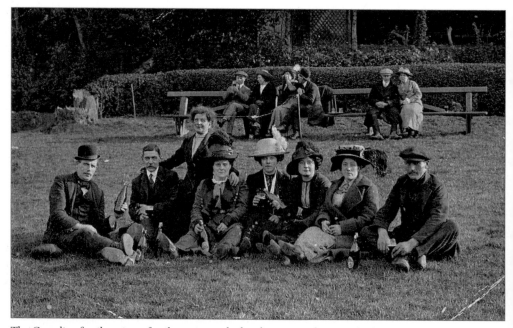

The Campling family enjoy a family outing and a bottle or two of Morgan's ales one Sunday afternoon on Chapel Field Gardens in 1910.

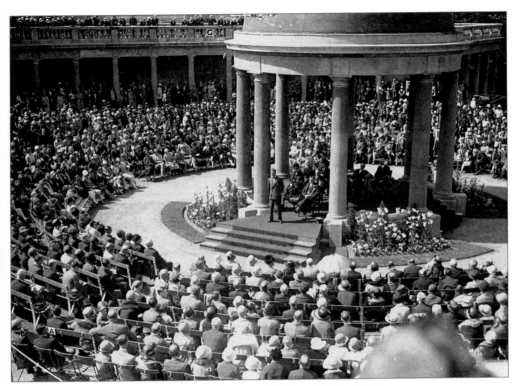

The opening of Eaton Park by HRH Edward, Prince of Wales on 30 May 1928.

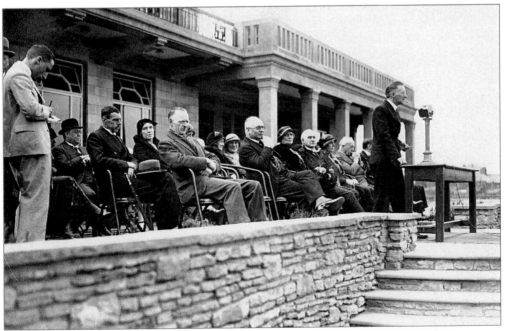

The Chairman of the Parks, Willie Walker, gives the address before Mr F.N. Holmes, Lord Mayor of Norwich, reopened the 17 acres of Waterloo Park after renovations and improvements costing £37,000 on 29 April 1933.

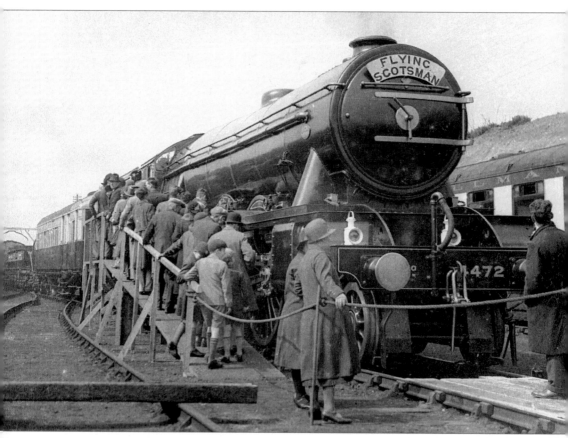

Some of the 15,000 visitors to the LNER Rolling Stock Exhibition, held at Thorpe Station on 2–3 May 1931, get a chance to have a closer look at No. 4472 Flying Scotsman. The event, opened by the Lord Lieutenant of Norfolk, Mr Russell Colman, also gave the public their first chance to see the 'largest, most up-to-date engine in all England'; known as the 'Hush-Hush' engine, this train weighed 166 tons and was 76 ft long. Beside this great engine was the new type shunting engine, the tiny 'Sentinel'. They were labelled 'Dignity' and 'Imprudence' respectively.

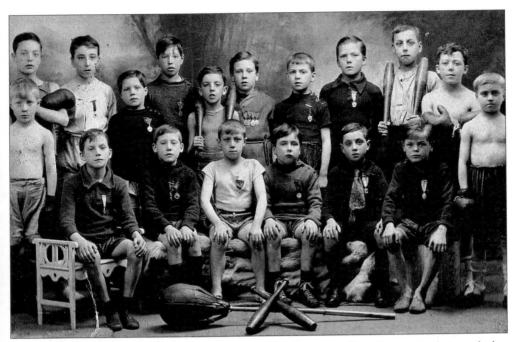

Proudly wearing their sports medals, these boys are from the Priory Gym; they were photographed at Read's Studios on Wensum Street, *c.* 1910. The gym stood just off Barrack Street, but was demolished when Jarrold's extended its printing works.

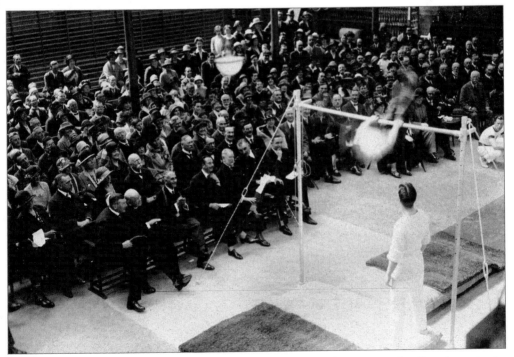

A gymnastic display at the Norwich Lads Club on King Street for the occasion of its formal opening by HRH Prince Henry, Duke of Gloucester on 2 June 1925.

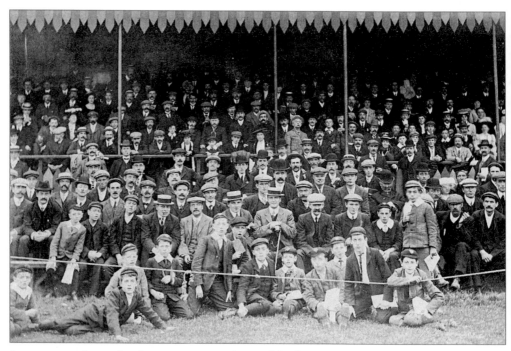

An eager crowd poses for the camera to record one of the first pictures of Norwich City Football Club fans at the beginning of the twentieth century. They are on the Corporation-owned Newmarket Road Ground where the team played its first matches.

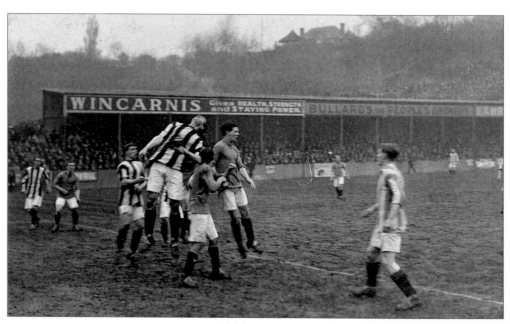

Finding its feet in the professional game, the club moved on to a new ground with larger stands where they saw in the new season in 1907. Called 'The Nest', it stood on Rosary Road on the site of the old chalk pit. Here, Norwich City skipper Sam Wolstenholme is heading the ball in the FA Cup second round replay against Bristol Rovers on 6 February 1913, which ended in a 2–2 draw.

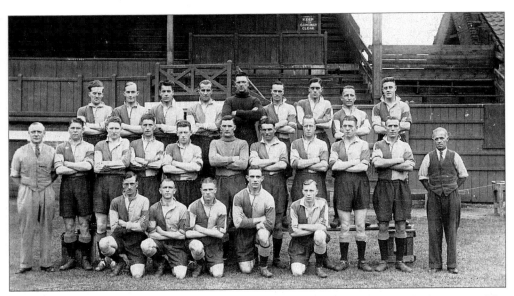

The line-up for Norwich City Football Club, 1932/3, when they played one of the final seasons at 'The Nest'. Back row, left to right: Smith, Thorpe, Keeling, Ramsay, Wharton, Keating, Robinson, Murphy, Burditt. Middle row: R.G. Young (trainer), Brown, Scott, Lockhead, Williamson, Robinson, Hannah, Blakemore, Hunt, Scott, A. Hawes (assistant trainer). Front row: Woolaghan, Pegg, Bell, Wilson, Spencer.

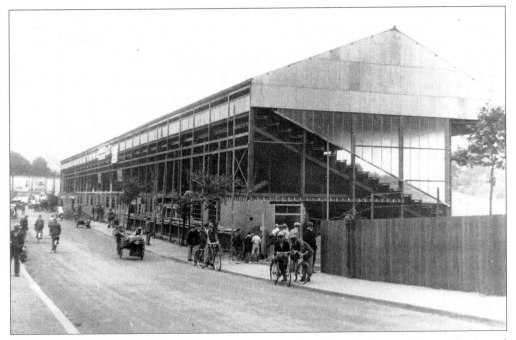

In 1934 the Football Association informed Norwich City that 'The Nest' was inadequate for Second Division football. Consequently, a new ground was found on Carrow Road with stands erected by Boulton & Paul. The fine new stadium was opened on 31 August 1935 by Mr Russell Colman, Lord Lieutenant of Norfolk.

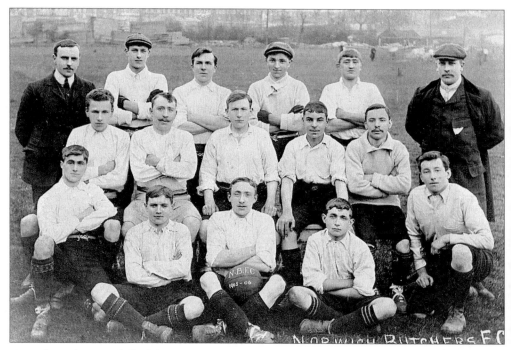

Norwich Butchers Football Club, 1905/6 season. One of the many such teams made from firms, trades and even local regiments across the city that competed in the Norwich Charity Cup League in the early years of the twentieth century. Norwich Butchers went on to become the Norwich Amateurs in 1910.

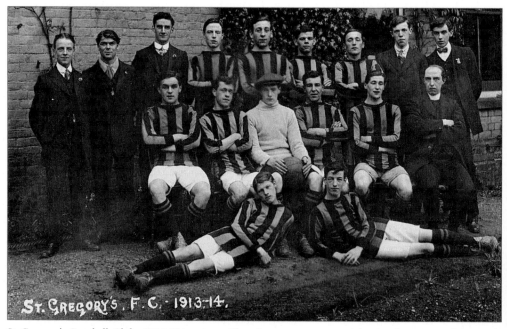

St Gregory's Football Club, 1913/14 season. Church teams were certainly popular, most of the city's churches having representation in their own hotly contested league. St Gregory's FC ceased for the duration of the First World War and was never reinstated as most of the players were maimed or killed in the conflict.

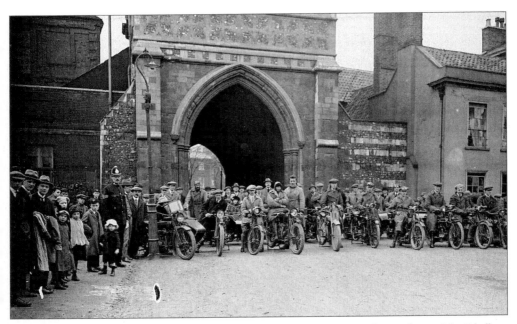

What about this line up! These are Norwich Vikings Motor Cycle Club members in front of the Ethelbert Gate in the Cathedral Close, *c.* 1928. They are awaiting the start of their reliability trials which finished on Ringland Hills.

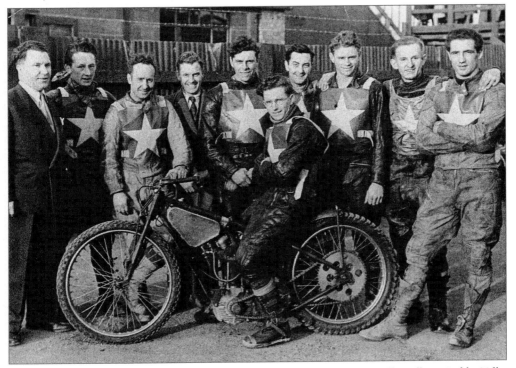

Norwich Stars at The Firs, *c.* 1951. Left to right: Fred Evans (manager), Bill Codling, Paddy Mills, Johnnis Davies, Jack Freeman, Phil Clarke (on his bike), Fred Pawson, Bob Leverenz, Fred Davies and Trevor Davies.

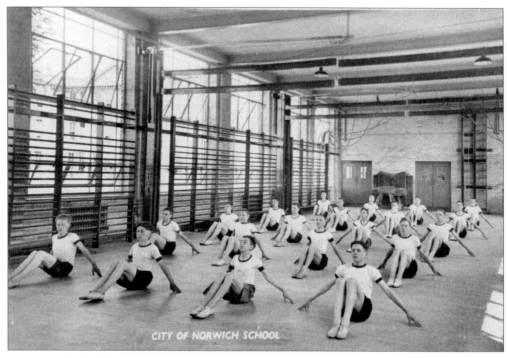

Boys pause for the camera during a physical training lesson at the City of Norwich School, *c.* 1938. The school was erected in 1910 on Eaton Road at a cost of £37,000 and took around 600 pupils. In 1937 Geoffrey Linton Thorp was headmaster, with twenty-seven schoolmasters and mistresses.

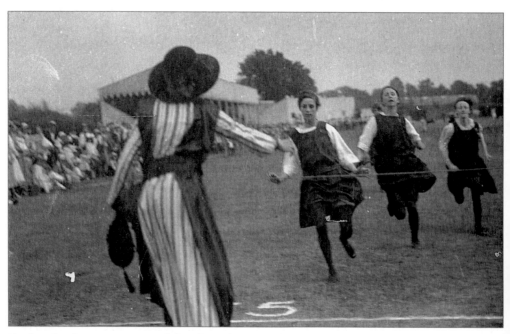

Heading for the tape are young ladies from the Norwich High School for Girls on Newmarket Road during their summer sports day, *c.* 1922.

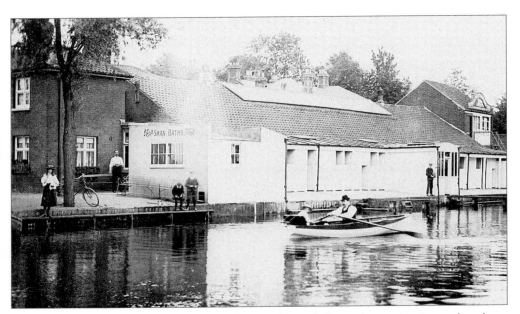

Swan Baths, Heigham Street. Built in 1879, this was the city's first indoor swimming pool, and was heated using steam from the nearby Swan Laundry. Home of the Norwich Swan Swimming Club, many galas were held at the pool until its closure in 1933.

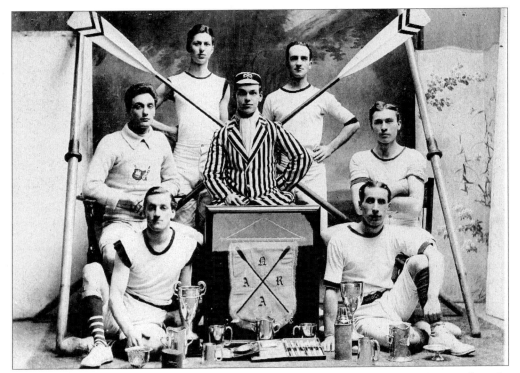

Norwich Amateur Rowing Association, c. 1910. The rowers were a familiar sight as they cut along the River Wensum and raced the passing trains from their clubhouse at Whitlingham, while in training for four-oared rowing and sculling championships.

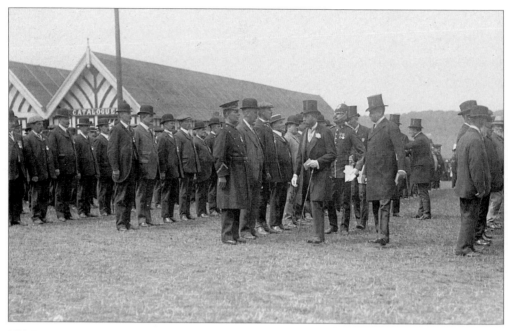

HM King George V inspecting over 200 old soldiers and sailors of the Royal Norfolk Veterans Association at the Royal Agricultural Show at Crown Point, Trowse, Wednesday 28 June 1911. The king's visit was the highlight of the five-day show. He is accompanied by Captain Anthony Atthill MVO, who was the founder and chairman of the association.

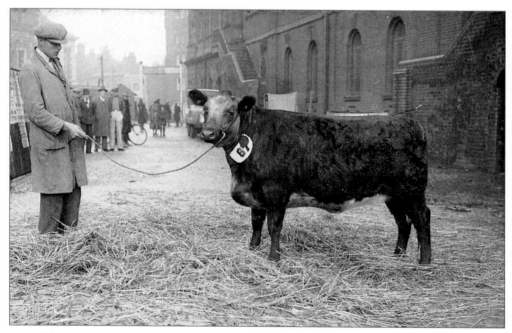

One of the prize beasts from the Norfolk and Norwich Fat Stock Show held at the Agricultural Hall in 1934. In the words of Walter Rye, if a man visits Norwich 'and says he has seen better cattle or fairer women elsewhere – well, don't believe him'.

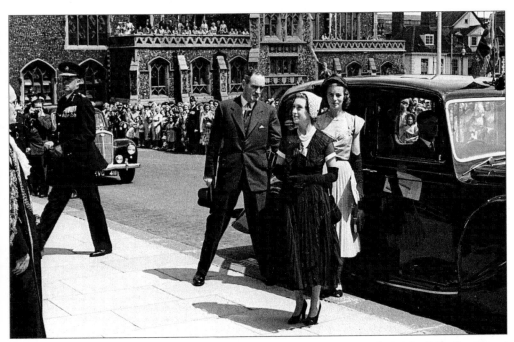

Princess Margaret arriving at the City Hall on her first official visit to Norwich, 8 July 1952. She opened the new orthopaedic operating theatres at the Norfolk and Norwich Hospital and then attended a civic reception at the City Hall.

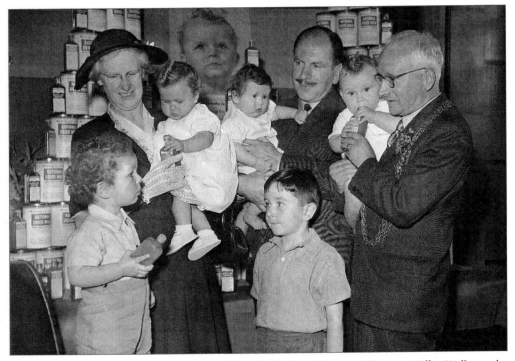

Pictured with three of Norwich's 'bonniest babies' is the Lord Mayor, Alderman Willie Walker, who headed the Ministry of Food, Eastern Region, Welfare Foods Campaign in August 1952.

'Billy Bluelight', a true Norwich character. Born William Cullum in 1859, one of his favourite entertainments was to race the SS Jenny Lind from Foundry Bridge to Great Yarmouth calling out the rhyme: 'My name is Billy Bluelight, my age is 45. I hope to get to Carrow Bridge before the boat arrive.'

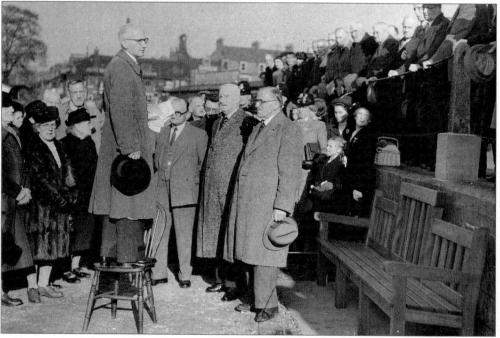

'Billy Bluelight' died on 10 July 1949, aged 90. Public subscriptions for a suitable memorial to him paid for a bench by Foundry Bridge; here the ceremony is being conducted by Willie Walker, Chair of the Parks.

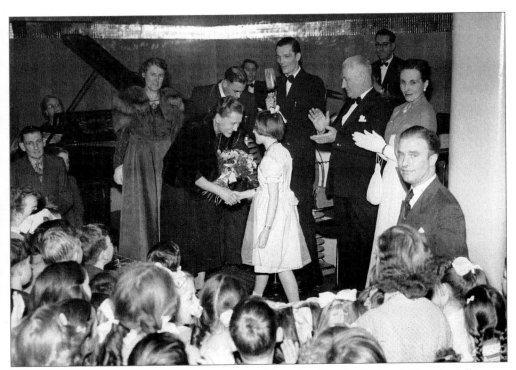

Lady South being presented with flowers at the first children's ball at the Samson & Hercules Ball Room, 1956. Beside her is Sir Arthur South, Lord Mayor of Norwich. On the microphone is Geoffrey Fisher, Master of Ceremonies, and beside him are Mr and Mrs Charlie Morley and Jack Woods.

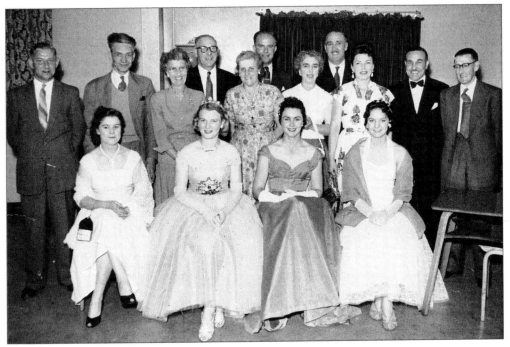

Princess of Industry night at the Federation Club on Oak Street, *c.* 1960.

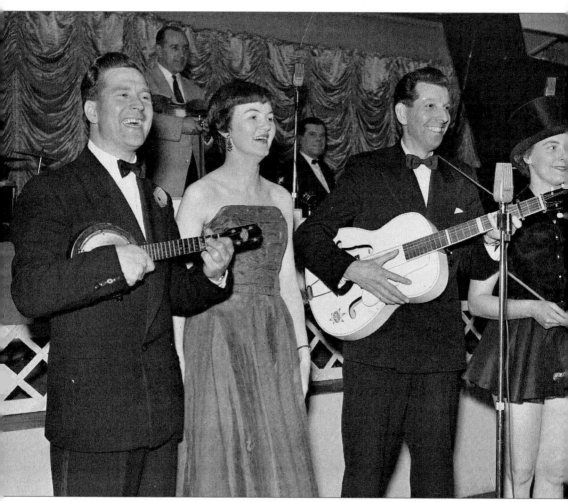

A laugh and a song or two to be had here with the line-up of some of the popular entertainers on the Norwich club circuit in the 1960s. Left to right: Phil Johnson, Sheila Moore, Len Rudd, Beryl King.

EMERGENCY SERVICES AND DISASTERS

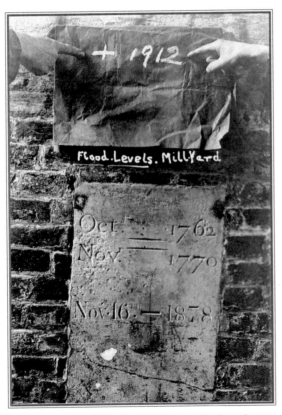

*Flood levels in Mill Yard in 1912 certainly show the city
is no stranger to such deluges.*

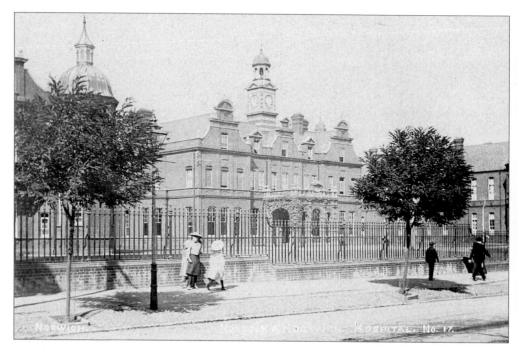

Norfolk and Norwich Hospital, *c.* 1910. Construction began in 1879 and the hospital was opened by HRH Edward, Prince of Wales on 17 June 1879. The total cost was £60,000.

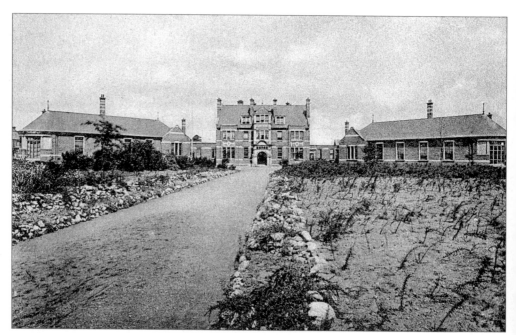

Jenny Lind Infirmary, Unthank Road, *c.* 1910. Founded in Pottergate in 1853 by the Swedish soprano, the infirmary was transferred to Unthank Road in 1900 and was reopened by the Prince and Princess of Wales.

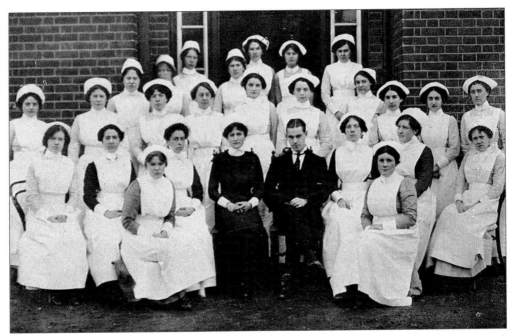

Medical staff of the Jenny Lind Infirmary for sick children, *c.* 1905. The new infirmary was equipped with forty beds. In the first year it saw over 98 in-patients and 1,227 out-patients.

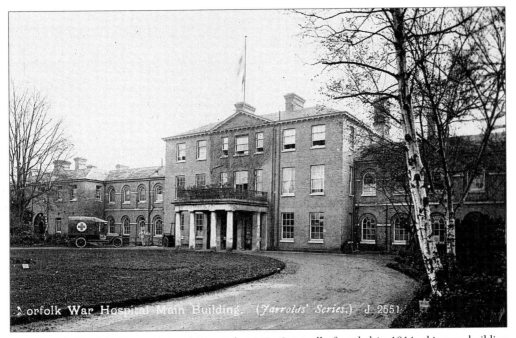

St Andrew's Norfolk County Mental Hospital, 1915. Originally founded in 1814, this new building opened in 1880. During the First World War it was temporarily occupied as the Norfolk War Hospital, nursing thousands of wounded brought to the county from the front.

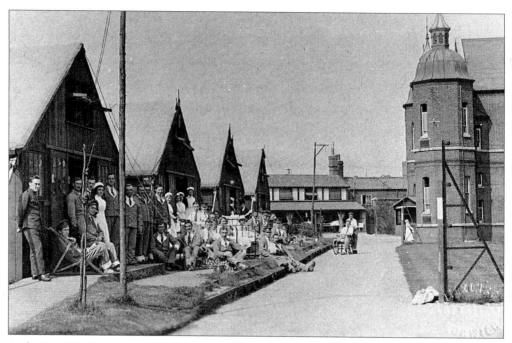

As the First World War progressed, the casualty levels rapidly grew to horrific levels. From 1915 these sheds next to the Norfolk and Norwich Hospital housed the increasing numbers of wounded brought to the county. Eventually tents were erected in the grounds as emergency wards.

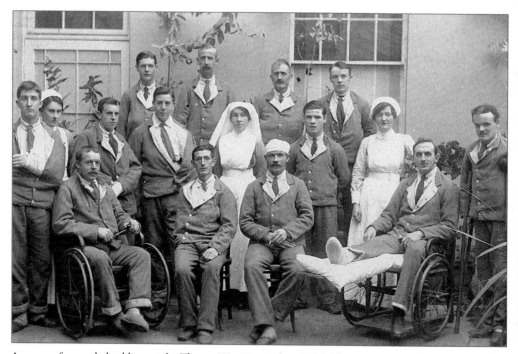

A group of wounded soldiers at the Thorpe War Hospital, *c.* 1916. They are wearing the 'Hospital Blue' uniform with scarlet ties. This was not only for convalescing but also for identification, especially if they wandered into a pub which was strictly out of bounds.

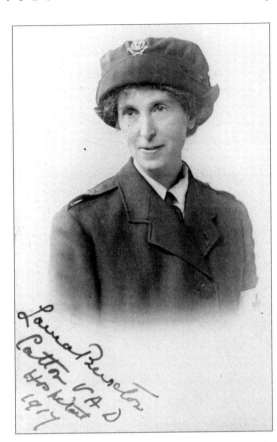

Miss Laura Buxton, Matron of Catton Hall
VAD Hospital, 1917.

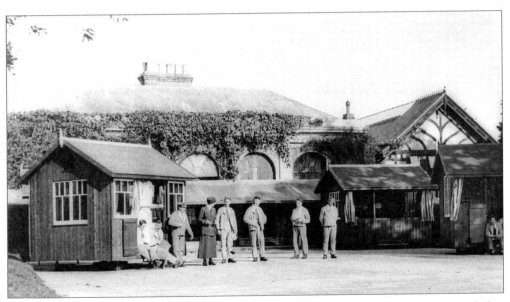

Eventually the hospitals could not cope and across the county large country houses were seconded to
become Voluntary Aid Detachment Hospitals for convalescent troops. This is Catton Hall VAD Hospital
which had twenty-seven beds. Between 1915 and 1919, 668 patients were treated here.

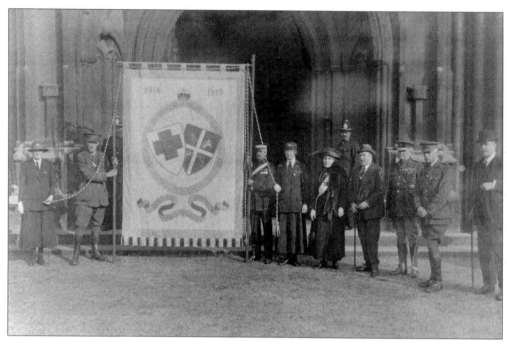

The banner presented to Norwich Cathedral by the Norfolk Branch British Red Cross Society and Order of St John of Jerusalem VAD Hospitals at the Thanksgiving Service on 18 October 1919.

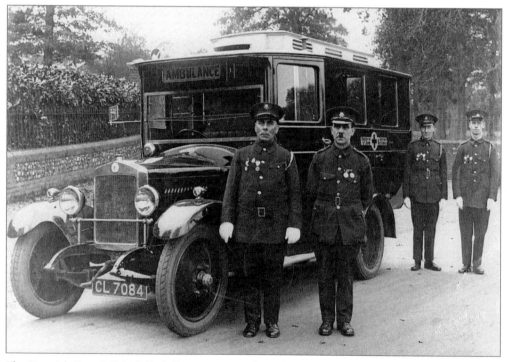

The Norwich Branch British Red Cross Society and Order of St John of Jerusalem Joint Ambulance Committee ambulance and crew, c. 1920.

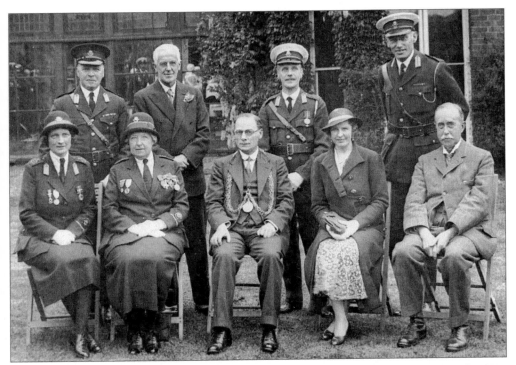

The opening of the British Red Cross Society (Norwich Division) headquarters on Unthank Road, 4 June 1934. Back row, left to right: W. Marriott MB, Richard Jewson JP, H.J. Coan, C.W. Steel MBE. Front row: Mrs Sargent, Mrs Cator OBE, Lord Mayor of Norwich Alderman F.C. Jex JP, Lady Ballance, F.H. Barclay JP.

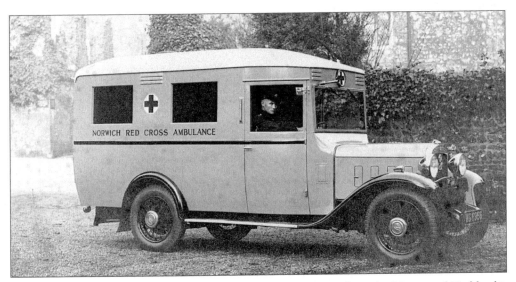

Norwich Red Cross Ambulance, 1933. Following a formal request from the Ministry of Health, this was the first city ambulance to serve the surrounding area. The local Red Cross and St John Ambulances were and still are supported totally by charity donations. Along with the police ambulance and the local authority hospital car, they were the only ways to get to hospital until 1970 when the Norfolk County Ambulance Service became a service in its own right.

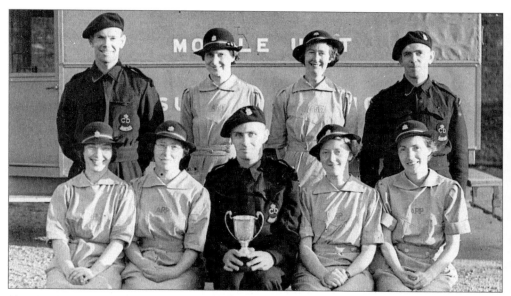

Thorpe Civil Defence Mobile Unit, *c.* 1940. With the creation of the Air-Raid Precautions service and Civil Defence in the 1930s, many mobile unit ambulances were established across the country sponsored by local councils. Their worth was undoubtedly proved during the blitz.

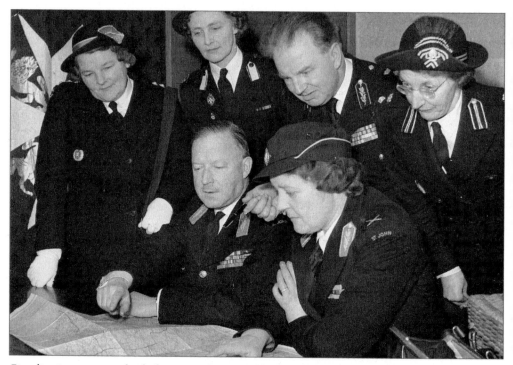

Coordinating rescue and relief services during the horrific floods of 1953 are the senior officers of Norfolk St John Ambulance Brigade at their headquarters on Castle Meadow. Standing, left to right: Mrs D.J. Farrow (Superintendent), Lady Cook (County President), Sir Thomas Cook (County Commissioner), Mrs J.H. Yull (County Secretary). Seated at map: Brigadier T. Daly (Assistant Superintendent-in-Chief), Mrs B. Grosvenor (Assistant Superintendent-in-Chief).

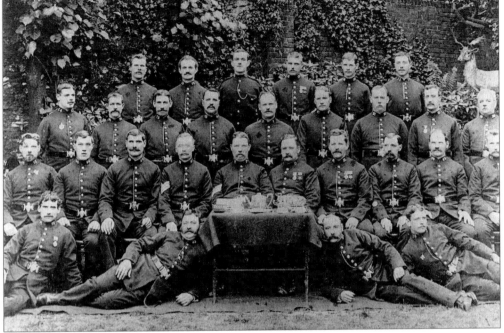

Norwich City Police Swimming Club, 1896. Back row, left to right: PCs Ward, Giles, Piercey, Sissen, Horner, Golden. Middle row: PCs Capon, Smith, Hardey, Freestone, Bloomfield, Small, Holland, Williamson, Ridley. Seated: PCs Woods, Rollett, Brown, Sgt. Martin, Sgt. Hardy, Sgt. Snell, PCs Wentford, Brown, Wailey, Watts. On floor: PCs Sayer, Woods, Beeston, Harrison.

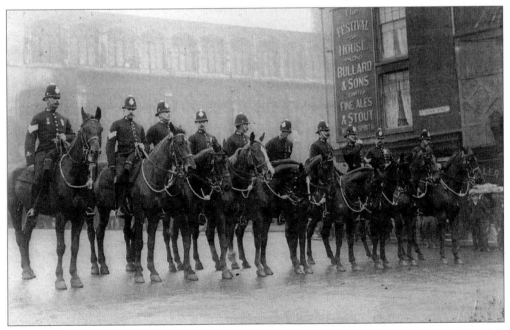

Mounted Police Section on St Andrew's Hall Plain ready to escort the parade and entourage of HM King Edward VII during his visit to Norwich on 25 October 1909.

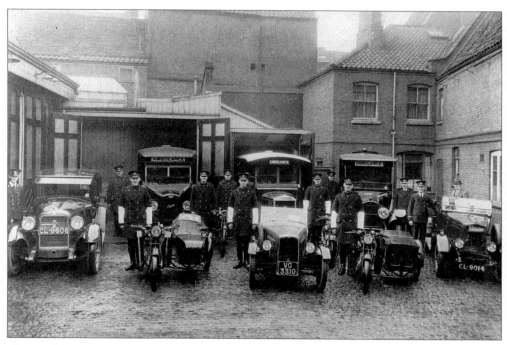

Three ambulances and the patrol vehicles of the Norwich City Police Highways Department at their depot in Pottergate, *c.* 1933.

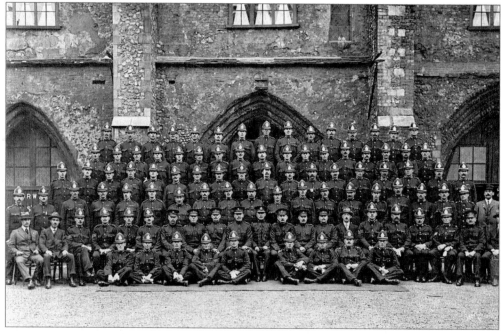

B Division, Norwich City Police at St Andrew's Hall, May 1920. John Henry Dain, Chief Constable of Norwich from 1917 to 1943, is seated in the centre of the group.

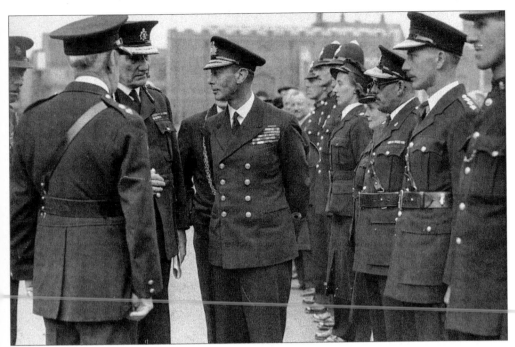

Chief Constable J.H. Dain OBE discusses the fine parade of policemen and policewomen with HM King George VI during his visit to Norwich on 13 October 1942.

Norwich City Special Police Constable Charles 'Oliver' Goldsmith. Having served in the Norfolk Regiment and the Royal Naval Division during the First World War, he answered the call of the 'Specials' in the Second World War. One near miss occurred as he bicycled home from his patrol along Sweetbriar Road. The area was strafed with machine-gun fire from an enemy raider, so Charles dived into a nearby ditch narrowly avoiding the trail of shots chasing him up the road.

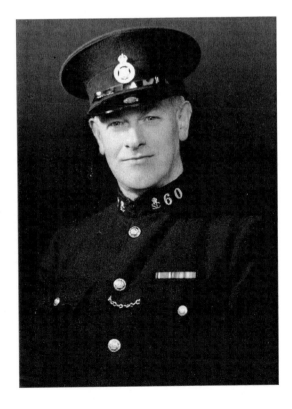

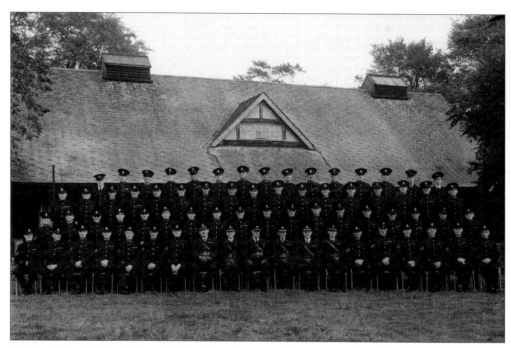

Division 3 Special Constables, *c.* 1942. Their district included Green Hills, Drayton, Mile Cross, New Catton and Sprowston.

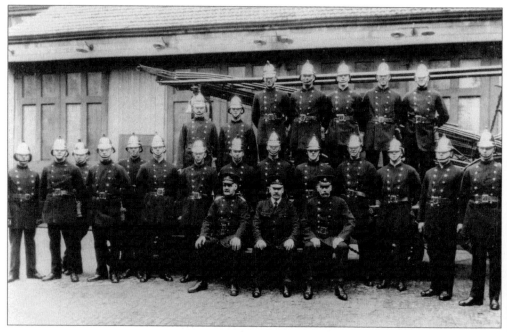

Police firemen at their station on Pottergate, 1930. This station opened in 1898 at a time when all police trained as firemen. As a permanent position it was greatly coveted, as the men received an additional 3s per week 'Fire Money' standing allowance, on top of police pay.

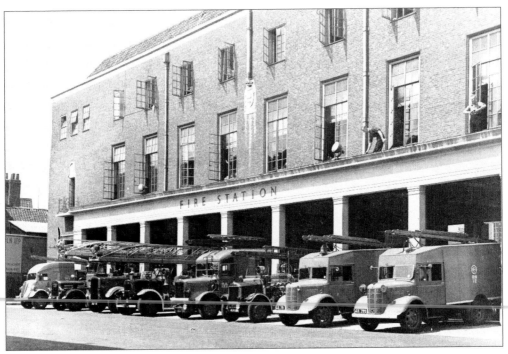

Bethel Street station with appliances, 1941. Built at a cost of £33,372, the station was opened by Alderman F.C. Jex, Lord Mayor of Norwich, on 9 November 1934.

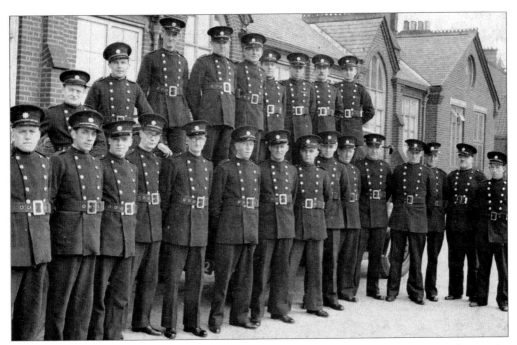

Norwich City Auxiliary Fire Servicemen, c. 1940. Operating from nine substations and with around a hundred Coventry Victor trailer pumps across the city, they stood ready and answered the call of their city through the darkest days of the blitz.

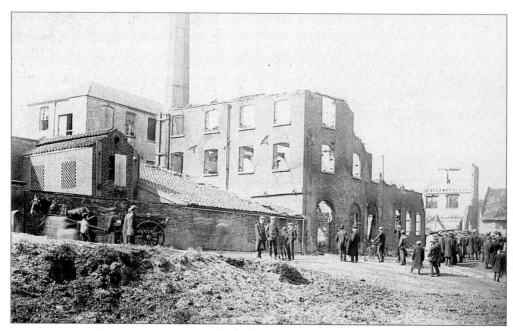

Locals and employees survey the burnt-out shell of Lakenham Mill, 1908. The mill, at the foot of Long John Hill, was discovered on fire around midnight on 31 March 1908, but by the time the City Fire Brigade arrived the building had been gutted. The fire was so intense that the flames could be seen from Norwich Market Place.

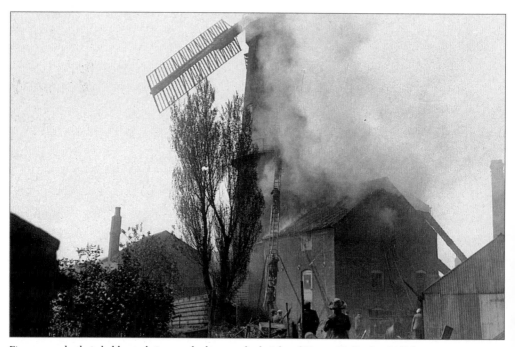

Firemen scale their ladder to bring up the hose at the height of Upper Hellesdon Mill fire on 4 May 1913. The mill, on Press Lane (off Aylsham Road), had its entire interior burnt out before the fire could be brought under control.

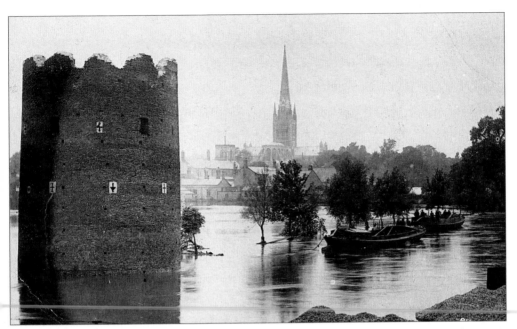

Cow Tower and the cathedral during the 'Great Flood' from 26 August to 1 September 1912. After a year of heavy rainfall and the deluge on 26 August when 7½ inches fell in 48 hours, Norwich was devastated with the worst flooding ever remembered.

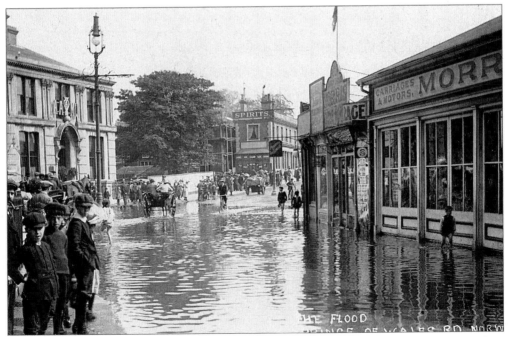

Crowds splash their way along Prince of Wales Road in front of the Automobile Association Offices during the 1912 flood.

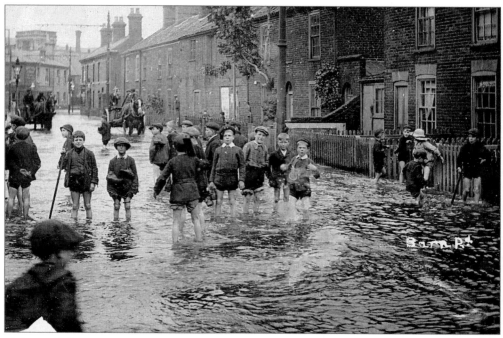

Children paddling outside their homes on Barn Road. Their schools were either closed because of the disaster or used as refuge centres for those made homeless in the 1912 floods.

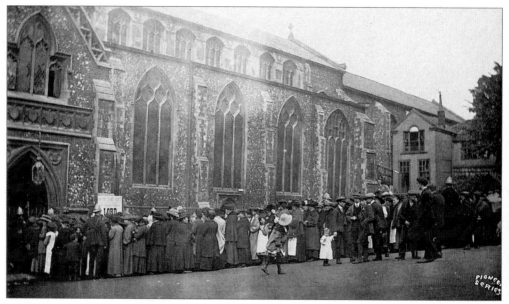

Some of the 6,000 applicants lining up in front of St Andrew's Hall to claim relief for flood damage, 1912. Damages amounted to over £100,000, with 15,000 people losing homes or property. Over 3,650 buildings were damaged or destroyed.

SECTION FOUR

THE MILITARY

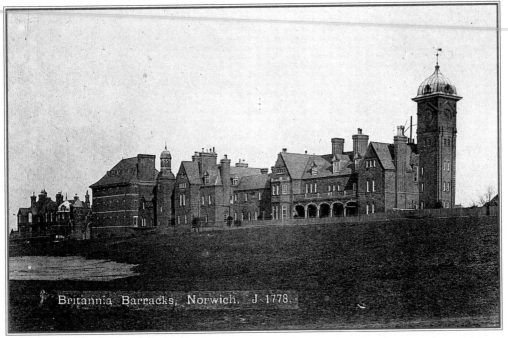

Britannia Barracks, Norwich. J 1778.

Britannia Barracks, c. 1910. This familiar sentinel has guarded the Norwich city skyline since it was built in 1886. Thousands of soldiers have passed through the famous gates to serve in their proud county regiment: the Royal Norfolk Regiment.

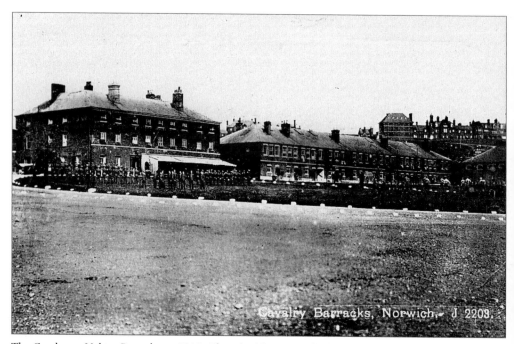

The Cavalry or Nelson Barracks, c. 1910. These buildings were built in 1791 on the site of an old manor house known as Hassett's Hall. Over the years they have hosted many different mounted regiments from all over the country, from the King's Royal Irish Hussars to the Scots Greys.

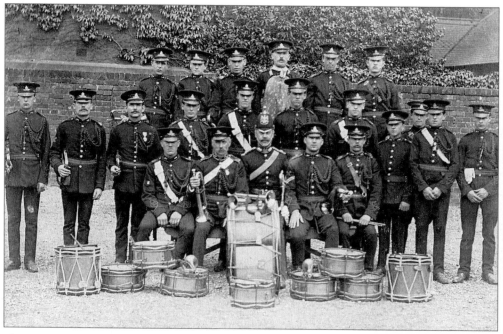

The prize-winning 1st Norfolk (Eastern Division) Royal Garrison Artillery Band in their parade yard at Ivory House, 1908.

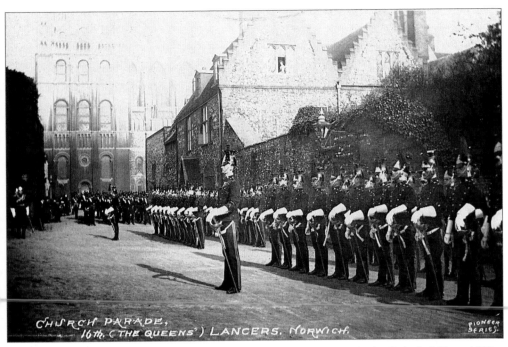

The fine spectacle of the church parade of the 16th (The Queens') Lancers in the Cathedral Close, 1910.

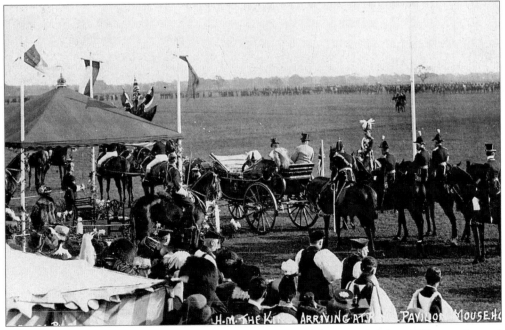

HM King Edward VII arrives at the pavilion on Mousehold Heath on 25 October 1909 to review and present colours to the various local new Territorial Force units. The event was filmed and the film still survives today, providing some of the earliest moving pictures of Norwich.

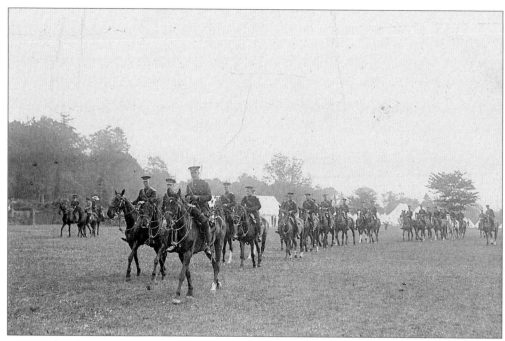

In mounted review order, members of the King's Own Royal Regiment Norfolk Imperial Yeomanry trot by on one of their summer weekend 'Field Days' at Trowse in 1908.

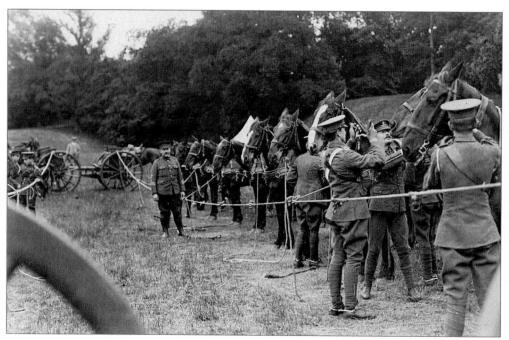

Horse lines are set up from the limbers as part of a weekend camp of the 1st East Anglian Royal Field Artillery at Crown Point, Trowse, 1909. They are under the keen supervision of Sergeant-Major J.G. Hayward.

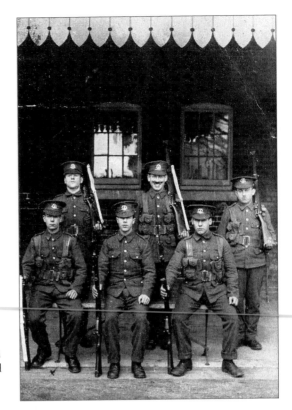

The smiling faces of Billy Burrell (seated front left) and his pals, off to war from Norwich city station, 1914. They could not have known what they were getting into in the 'War to end all wars'. I cannot help but wonder how many of these boys came home.

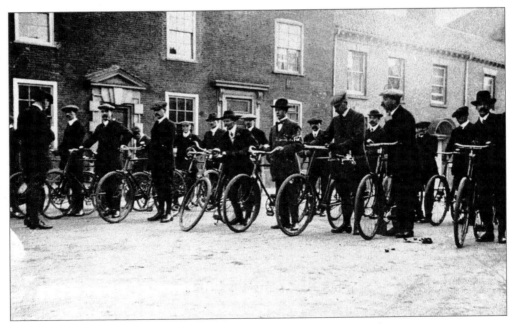

The men of the Cyclist Section, 1st City of Norwich Volunteers, on All Saint's Green, shortly after their first parade in August 1914. Eventually uniformed, they were the First World War equivalent of the Home Guard and were cruelly known as the 'Cripples Brigade' or 'England's Last Hope'.

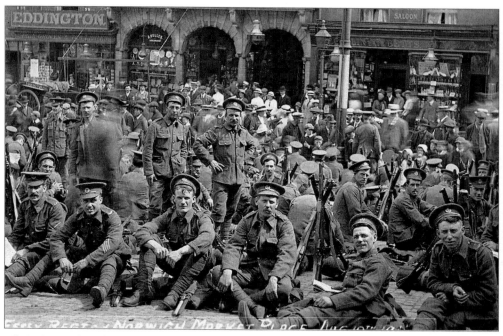

Filling the Market Place in front of the Royal Arcade are some of the men of the Essex Regiment, 10 August 1914.

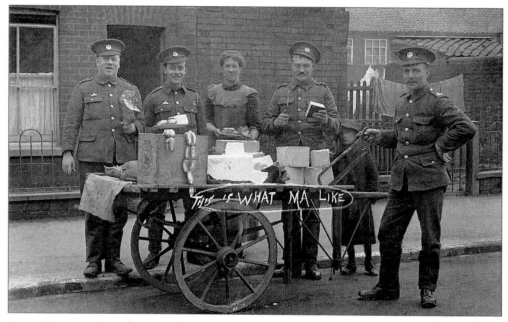

One of the ration barrows of the 4th (Service) Battalion, the Essex Regiment, on Waterloo Road, 10 August 1914. They are collecting supplies for some of the 4,000 troops of their regiment gathered in the Market Place.

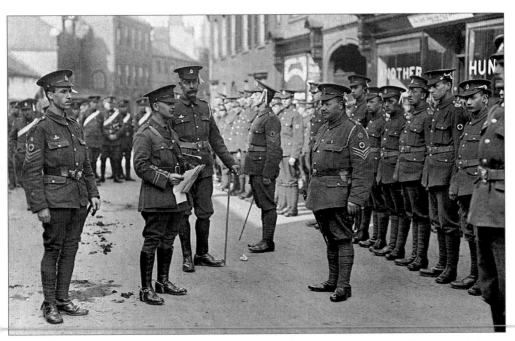

A recruiting parade for 'Another 100 Recruits' for the 2nd East Anglian (Territorial) Field Ambulance, Royal Army Medical Corps, in front of their headquarters on Bethel Street, 1915.

Sergeant-Major James Connell, who was Headquarters Instructor for the 2nd East Anglian (Territorial) Field Ambulance at 44 Bethel Street during the First World War.

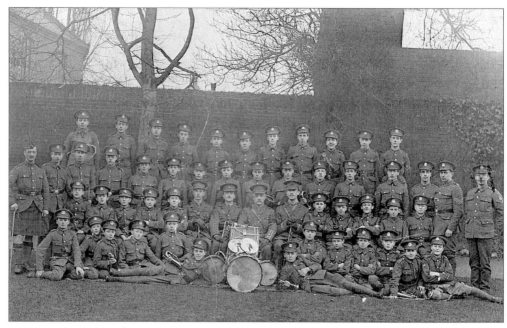

Norwich High School (Norfolk Regiment) Cadets and Band, 1918. Seated in the centre of the group is their commander, Captain J. George Chapman.

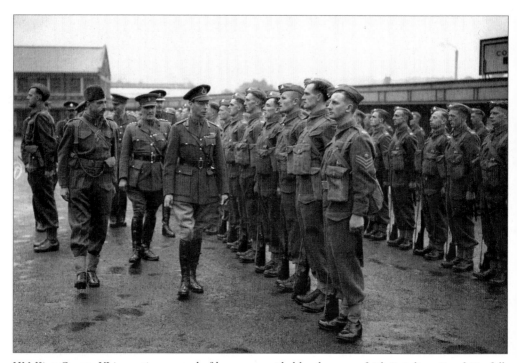

HM King George VI inspecting a guard of honour provided by the men of 4th Battalion, Royal Norfolk Regiment TA, at Thorpe station on 23 August 1940. The king passed through here on his way to inspect the coastal defence forces at Gorleston.

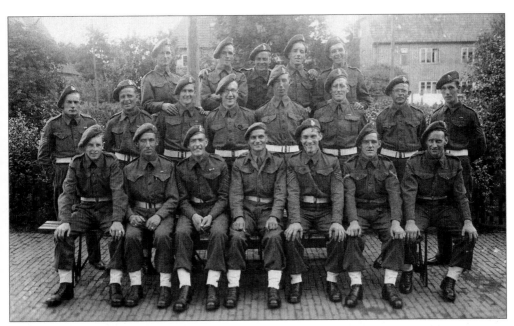

Some of the many men of Norwich who served in the 65th (Norfolk Yeomanry) Anti-Tank Regiment, Royal Artillery TA. Sadly, their gallantry throughout the war is not widely known; few regular or TA units could have been asked to do more. They served in the major battles and campaigns of the Second World War from Dunkirk, via the desert, to the fight through Europe to cross the Rhine.

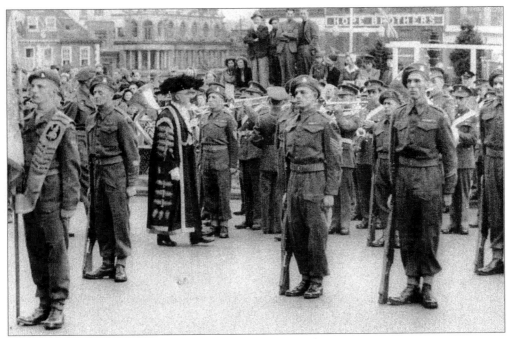

A proud Captain John Lincoln MC, on the left, holding the Regimental Colour, 3 October 1945. The Lord Mayor is inspecting the parade on the occasion of the freedom of the city being granted to the 1st Battalion, Royal Norfolk Regiment.

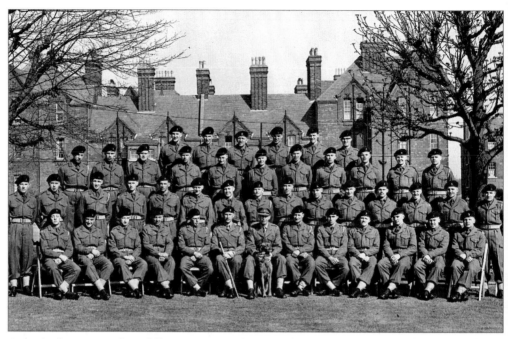

Gristock Platoon, Royal Norfolk Regiment, intake 10 March 1958. These are some of the last of the thousands of National Servicemen who passed through Britannia Barracks during the years of National Service. For many of those years squaddies no doubt recall the formidable Depot Regimental Sergeant-Major Bert 'Winkie' Fitt DCM.

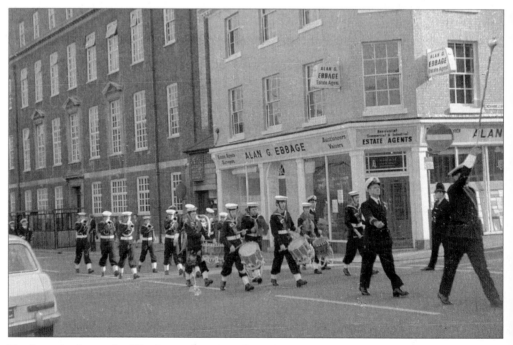

The drums lead a parade of Sea Scouts along St Andrews Street, c. 1968.

THE SUBURBS

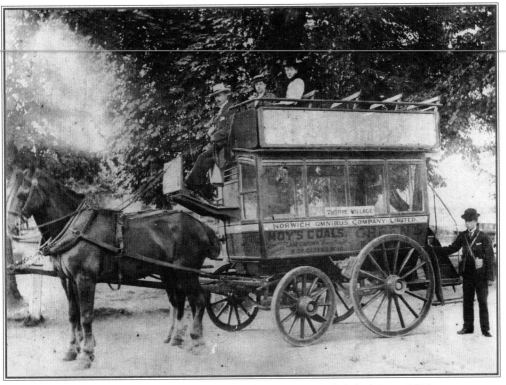

One of the last double-decker tuppenny buses standing on Thorpe Green, 1895.

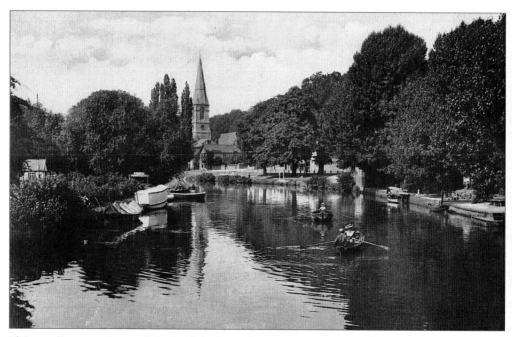

Thorpe village, on the north bank of the River Yare, *c.* 1912. Between the trees is the spire of St Andrew's Church, built in 1866 near the site of the earlier ruined church.

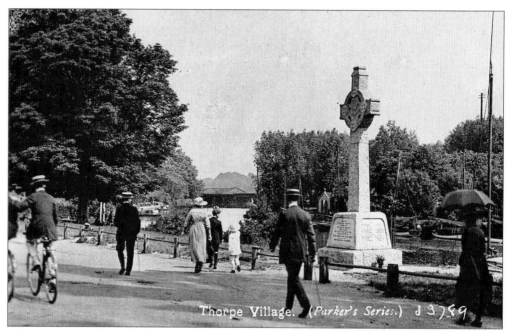

Thorpe Village. *(Parker's Series.)*

Thorpe Street, running beside the river, *c.* 1920. Prominent is the familiar landmark of the village's war memorial, erected in memory of the forty-two men of the parish killed in the First World War.

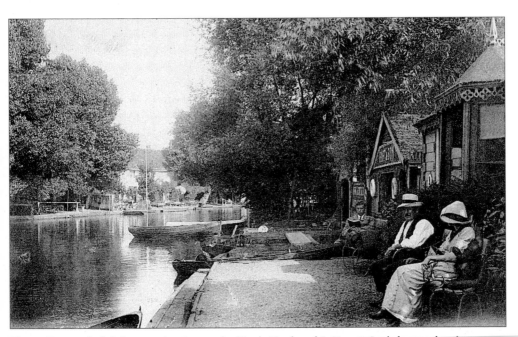

Thorpe Ferry, which led across the river to the King's Head, and J. Hart & Son's boat and yacht owners, *c.* 1908.

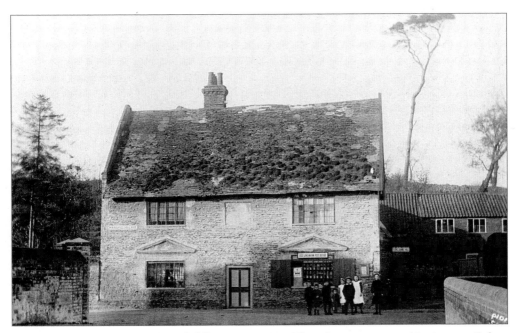

Old Lakenham post office on Mansfield's Lane, *c.* 1905. The sub-postmaster at this time was Robert Rayner.

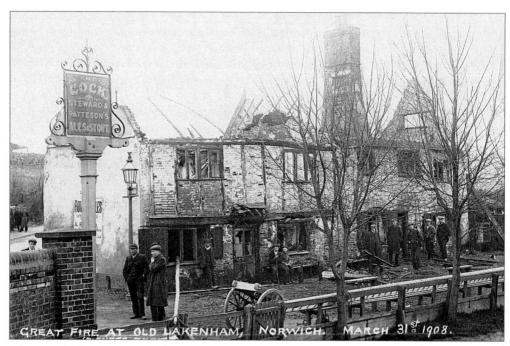

When Lakenham Mill caught fire on 31 March 1908 the flames were fanned by high winds. Those same winds carried sparks on to the dry thatched roof of The Cock Inn, setting it alight and consequently gutting the old pub and the adjacent house. The pub was rebuilt shortly after and it is still serving today.

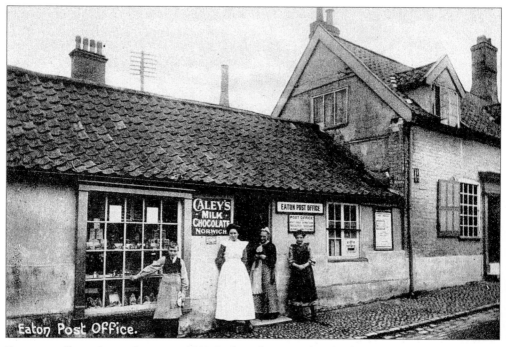

Eaton post office and general stores, c. 1900. In those days it was kept by the Featherstone family.

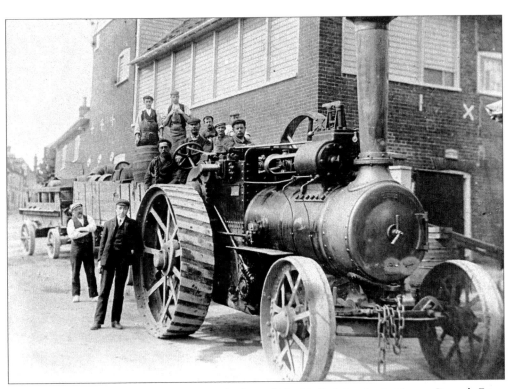

The traction engine of Arthur Farrow, steam hauliers of Mattishall, delivering to Cooper-Brown's Eaton Brewery on Eaton Street, *c.* 1904.

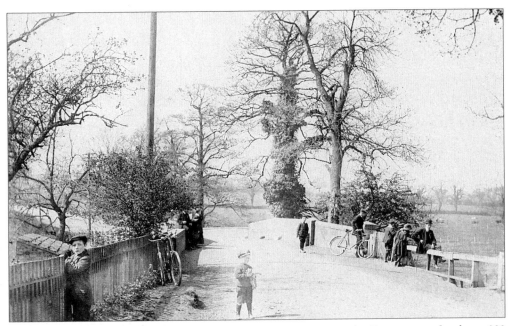

Earlham Bridge, *c.* 1910. Built in 1774, this bridged the River Yare into the Gurney estate for almost 200 years until it became unstable and was finally demolished in 1971.

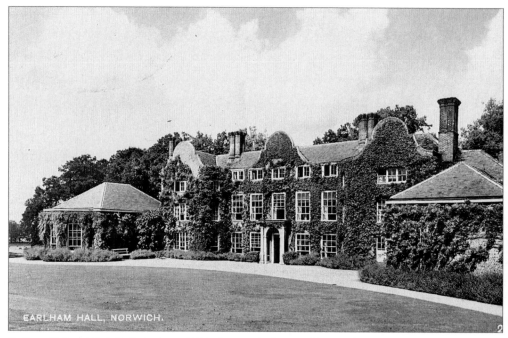

Earlham Hall, *c.* 1925. Built in about 1642, this was the home of the Quaker Gurney family, well-known local bankers, from 1786 to 1912. Here, John Gurney raised eleven children, one of whom, Elizabeth, became known throughout the nation as Mrs Fry the prison reformer.

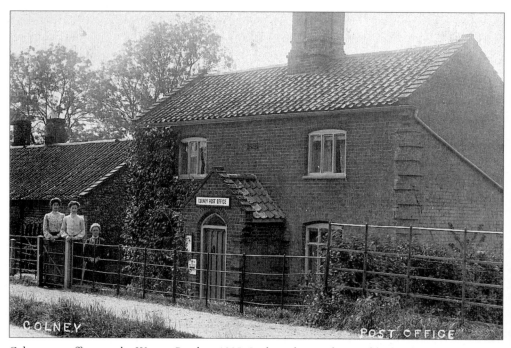

Colney post office, on the Watton Road, *c.* 1905. In those days mail arrived by handcart from Norwich seven days a week, and the nearest telegraph office was 3 miles away in Eaton.

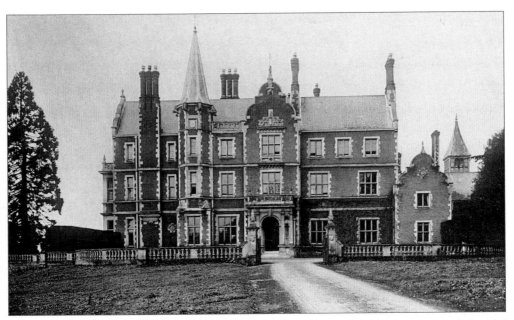

Taverham Hall, standing in around 100 acres of estate land, *c.* 1910. The decaying structure which stood here in 1858 was rebuilt in the Elizabethan style by the Revd John Nathaniel Micklethwaite MA. Today it is occupied by a preparatory school.

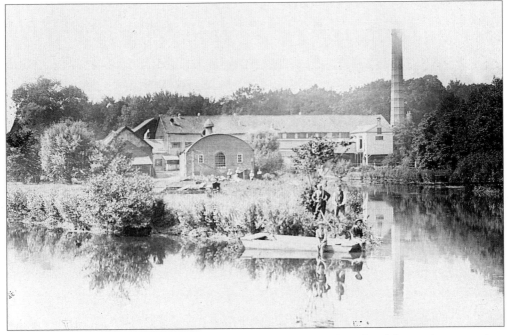

Taverham Mills, *c.* 1900. The last of the Norfolk paper mills, it had produced fine quality paper since 1700 for everything from banknotes to *The Times* newspaper. Ceasing production in 1901, the old mill was demolished in 1920.

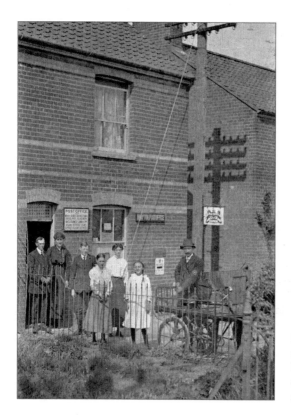

Drayton post office and the Smith family who ran it in 1915. The postman stands with his bicycle beside the mail cart which brought deliveries here to and from the Norwich sorting office twice a day, six days a week.

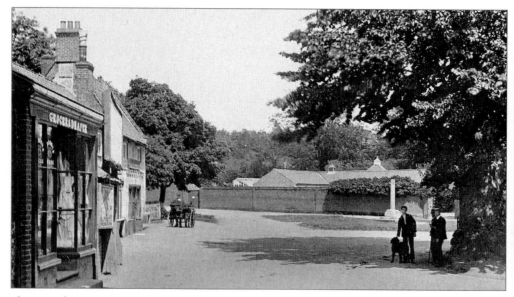

The original Drayton Stores, kept by William Jeckell as grocer and draper, beside the Red Lion in 1903. On the right are the remains of a thirteenth-century wayside cross. It had a Norman French inscription now replaced with a translated bronze tablet, which promises a number of days' pardon for those who pray for the souls of William Bellemonte and his wife Joanna. These words were no doubt observed by pilgrims passing here en route to Walsingham.

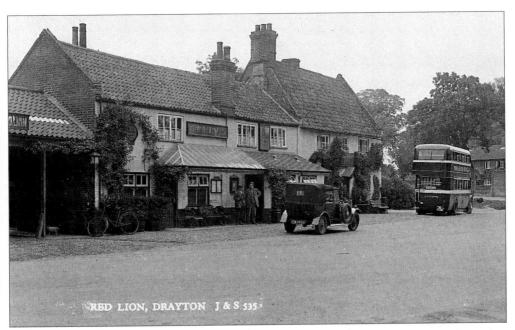

The Red Lion public house in Drayton, *c.* 1935. The signboard proudly bears the name of Charles Walter Neve, landlord of this pub as well as the Old Cock. The latter was popular with locals because of its discreet entrance, hidden from the watchful eye of the squire in his nearby hall.

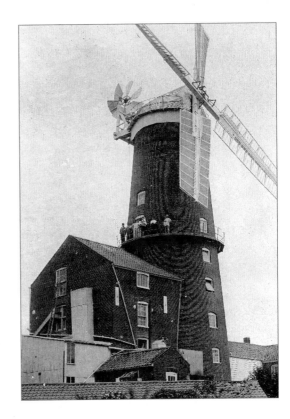

Upper Hellesdon Mill, when it was kept by Ephraim Witard, the corn and cake merchant, *c.* 1904. Originally built in the 1870s, it stood on Press Lane off Aylsham Road. One of the tallest mills in the city, it was burnt out on 4 May 1913.

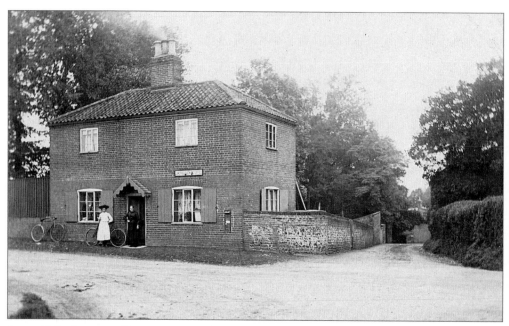

Lower Hellesdon post office, *c.* 1912. At the door is Mrs Emma Blake, the sub-postmistress. According to Kelly's Directory, at that time the post office served a total population of 826, including 59 officials, their families and 495 inmates of the Norwich City Lunatic Asylum.

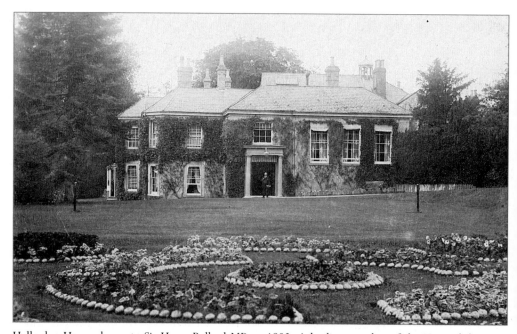

Hellesdon House, home to Sir Harry Bullard MP, *c.* 1902. A leading member of the Norwich brewing family, he was returned to parliament and was Mayor of Norwich twice. He died in December 1903.

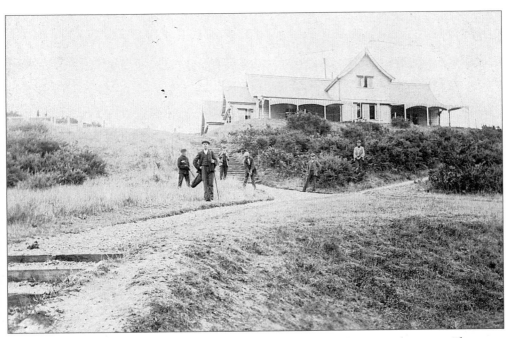

Caddies practising in the rough on Hellesdon Golf Links at the turn of the twentieth century. The course is the home of the Royal Norwich Golf Club which was founded in 1893.

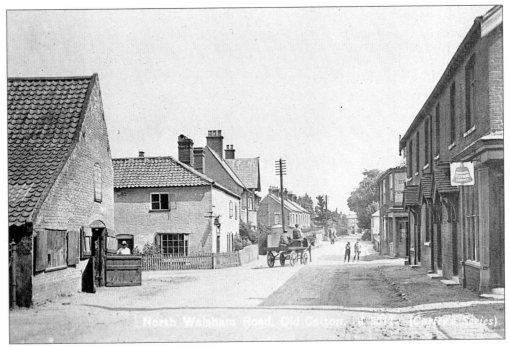

North Walsham Road, Old Catton, *c.* 1908. This was part of the route of the Norwich to North Walsham Turnpike which opened in 1797. A throw-back to those days was the old forge on the left kept by William Badcock.

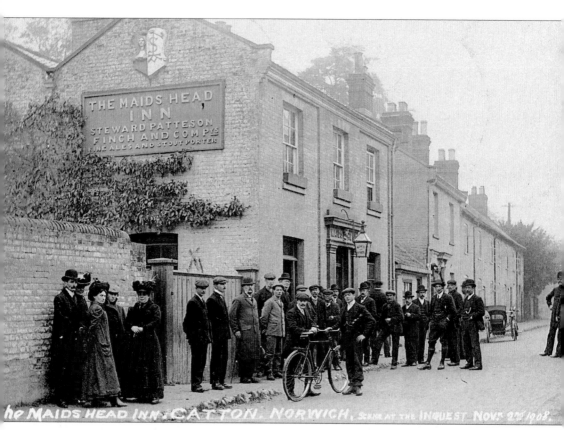

Crowds gather in front of the Maid's Head Inn, Spixworth Road, Old Catton on 2 November 1908 to hear the result of the inquest into the death of 19-year-old Nellie Howard whose body was found nearby. The verdict was returned as wilful murder. Her suitor, Horace Larter, was brought to trial, convicted and hanged at Norwich Gaol for the crime.

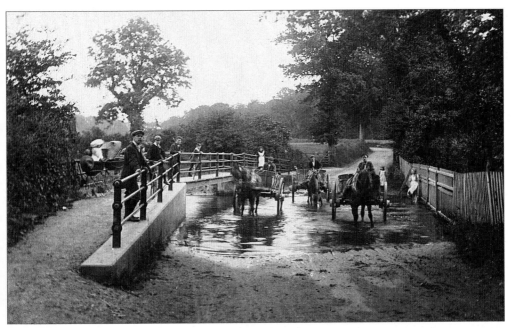

Carts pause for the camera in the old ford on Water Lane, Costessey, just after the turn of the twentieth century.

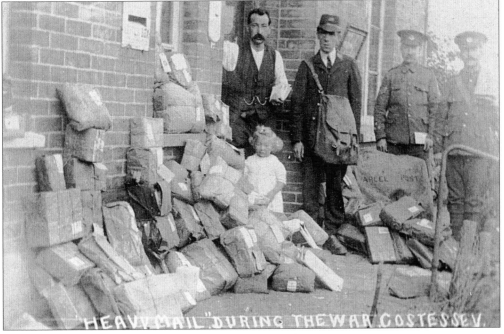

A somewhat daunted postman surveys the great pile of 'heavy mail' on Costessey station, July 1915. Most of the parcels were destined for the men of the East Riding of Yorkshire Imperial Yeomanry, tented at the time on Costessey Hall Estate.

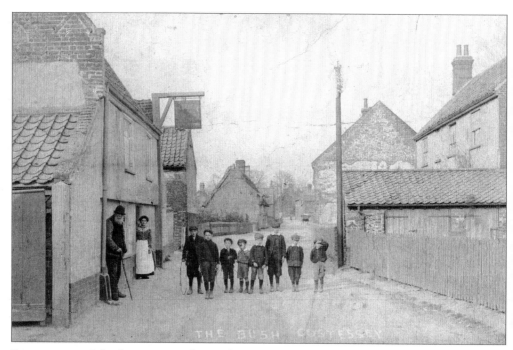

Everyone stopped for the camera, making a charming view of Costessey Street, *c.* 1902. On the left is The Bush public house, visited many times and painted by Sir Alfred Munnings. He described the hostelry as a place of ill repute, a haunt of harpies and members of the trotting fraternity of Norwich.

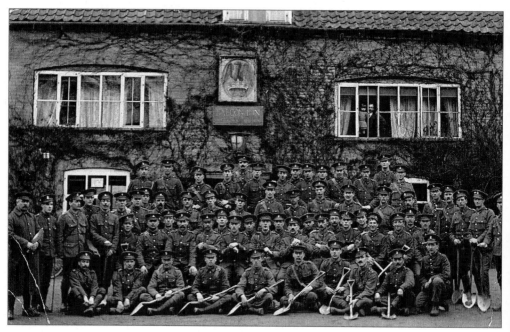

A Pioneer Company of the Northumberland Fusiliers form up for the camera in front of The Falcon public house in Costessey, on their way to camp at Mundesley in 1916. Even the landlord and his inquisitive young daughter lean from the upstairs window.

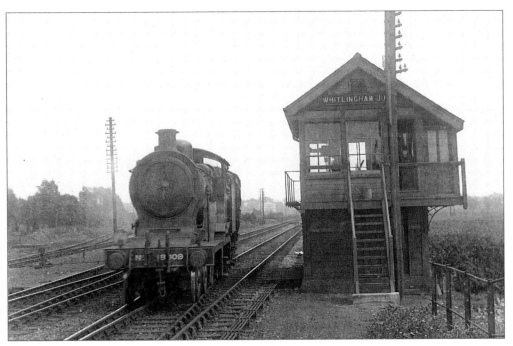

The Whitlingham signal-box, *c.* 1930. Still familiar today, this is the railway 'entrance gate' to Norwich where the Yarmouth and Lowestoft railway branches join the Cromer line.

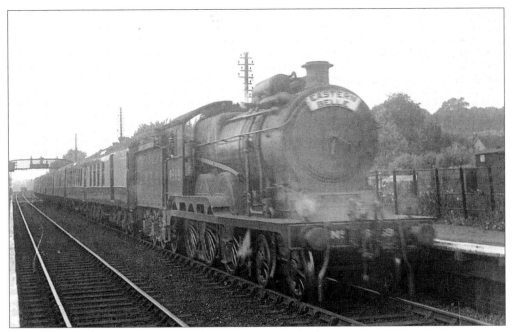

The 'Eastern Belle' express steams through Whitlingham Junction station on its way to the coast, *c.* 1930. Crowding the river banks as the 'Belle' passed would be city day-trippers enjoying a day by the river at Thorpe Gardens and Whitlingham Reach.

ACKNOWLEDGEMENTS

I gratefully extend my thanks to the following without whose generous help this book would not have been possible: Harry Barnard, Tony Bishop, Terry Davy, Eastern Counties Newspapers (Derek James and library staff), Imperial War Museum, Tim Nelson, Norfolk British Red Cross Society, Norfolk Constabulary, Norfolk Museums Service, Norfolk St John Ambulance Brigade, Norwich Central Library (Local Studies Department), Paul Segolo, Paul Standley, Philip Standley, for never failing to come up with 'just one more photograph', John and Pauline Walker, Jean Warnes, John and Kitty Warnes, Jack Woods

Thanks yet again to Terry Burchell for photographic wonders and special thanks to Ivan Moore and Robert 'Bookman' Wright for many interesting and informative conversations.

My heartfelt thanks as always to my family for their endless support and encouragement, especially my darling Sarah for always being there for this temperamental author.

By no means least, thanks to the many people it has been my pleasure to meet during the research into this book and to all those who have donated to or inspired my collection over the years. Finally, I sadly record the passing of my old pal George Clapham who was a mine of information on the characters of old Norwich and a true gentleman. He is greatly missed.

Visit our website and discover thousands of other History Press books.
www.thehistorypress.co.uk